PSC $^{11}/_{1J}$

The Best Dog in the World

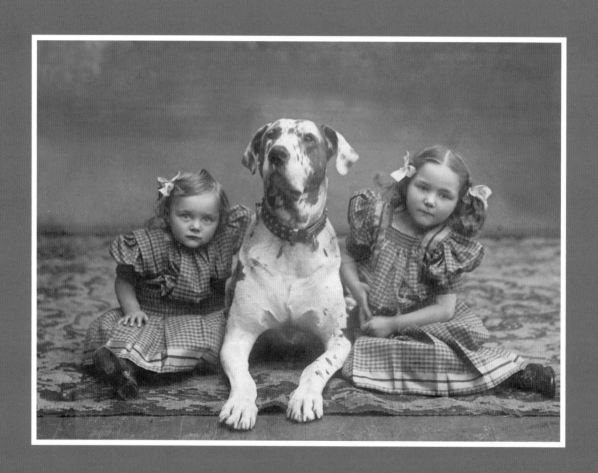

The Best Dog in the World

VINTAGE PORTRAITS of CHILDREN and THEIR DOGS

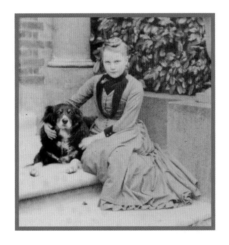

Donna Long

TEN SPEED PRESS

Berkeley | Toronto

Ten Speed Press
PO Box 7123
Berkeley CA 94707
www.tenspeed.com

Distributed in Australia by Simon and Schuster Australia,
in Canada by Ten Speed Press Canada, in New Zealand
by Southern Publishers Group, in South Africa by Real
Books, and in the United Kingdom and Europe by
Publishers Group UK.

Design by Catherine Jacobes Design, San Francisco

Library of Congress Cataloging-in-Publication Data
Long, Donna, 1967-
 The best dog in the world : vintage portraits of
children and their dogs / Donna Long.
 p. cm.
 Includes bibliographical references.
 ISBN-10: 1-58008-840-6 (alk. paper)
 ISBN-13: 978-1-58008-840-4 (alk. paper)
1. Photography of dogs. 2. Photography of children. 3.
Dogs—Pictorial works. 4. Children—Portraits. I. Title.
TR729.D6L66 2007
779'.329772—dc22 2006037611

First printing, 2007
Printed in China

1 2 3 4 5 6 7 8 9 10—09 08 07

Sources of Quoted Material

Axtell, Edward. *The Boston Terrier and All About It. A Practical,
Scientific, and Up to Date Guide to the Breeding of the American Dog.*
Battle Creek, MI: Dogdom Publishing Company, 1910.

Bristow-Noble, J. C. *Working Terriers: Their Management,
Training, Work, Etc.* 1919. Reprint, Warwickshire, England:
Read Books, 2004.

Caius, Johannes. *Of Englishe Dogges.* 1576. Reprint,
Warwickshire, England: Read Books, 2005.

Dear, H. C., and Hugh Dalziel. *Breaking & Training Dogs:
Being Concise Directions for the Proper Education of Dogs, Both for the
Field and for Companions.* 1903. Reprint, Warwickshire,
England: Read Books, 2005.

Eley, Major W. G. *Retrievers and Retrieving.* 1905. Reprint,
Warwickshire, England: Read Books, 2005.

Fuertes, Louis Agassiz. *The Book of Dogs.* Washington, D.C.:
National Geographic Society, 1919.

Glass, Eugene. *The Sporting Bull Terrier.* 1910. Reprint,
Warwickshire, England: Read Books, 2005.

To Astrid, the best dog in the world

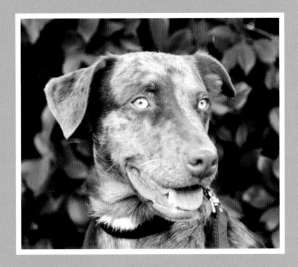

and to the rest of the pack,

Toby, Tessa, Sidney, Bruce, and Tuna

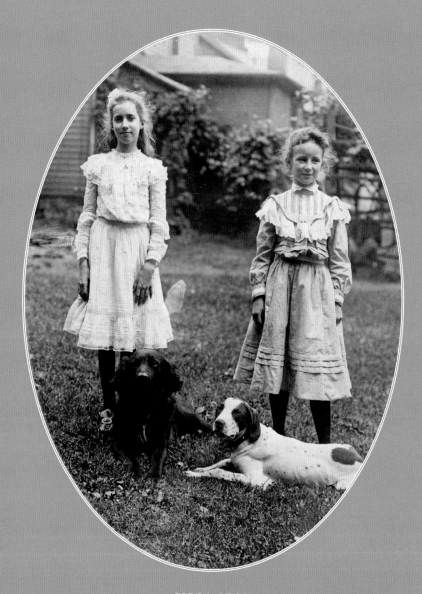

CIRCA 1905

Introduction

From photography's earliest moments in the 1840s, people have included their dogs in their family portraits. And why wouldn't they? The stereotype of the exceedingly serious face staring stiffly at the camera belies the fact that our ancestors were really the same as us: they laughed and cried at the same things, and they certainly loved their dogs with the same passion that we do.

A century and a half ago the family dog was perhaps an indispensable provider of food for the frontier table, perhaps she was a guardian or herder, or perhaps sprawling in laps was her only duty. Whatever their roles, it's clear that the dogs who fill these pages were beloved family members. After all, the very fact that they were included in family pictures at a time when very few photos were taken is telling commentary on their value to the family.

The photographs in this collection all date between 1875 and 1925, a period that also, coincidentally, witnessed the development of the majority of today's dog breeds. Thus, a perusal of these images is also an introduction to an important era in canine history.

Interest in identifiable purebreds, as we know them today, really began to take shape in the mid-1800s. By the 1880s, there are countless photos that clearly depict recognizably modern breeds—such as pugs, which were a fad in the mid-1880s. The American Kennel Club, with its emphasis on written breed standards and pedigree tracking, was founded in 1884.

Many breeds, however, weren't standardized until after the period covered in this book. It is interesting to identify a dog in an old photograph who mostly—but not entirely—corresponds to today's form, and to know that he is in the process of evolving into his current appearance. Boxers, for example, look quite different in early breed fanciers' club photos from the 1890s, and well into the 1920s there are images of boxers with muzzles that are longer and less upturned than they are today.

The greyhound is a notable exception; he has remained unchanged for centuries. He was certainly not a common dog on the American frontier, yet here he is, in Mayville, North Dakota, of all places, in the late 1880s: a perfect representation of the breed, panting after a brisk trot to the photographer's studio (page 84). How did the family acquire him and what was his role in their lives?

The mixed breed, however, is really the star of this collection. He sits proudly and patiently for the photographers in every conceivable form, from tiny fluffy playmate to sleek regal hunter. Certainly, for the children, each of these dogs, no matter how humble her origins, was the best dog in the world.

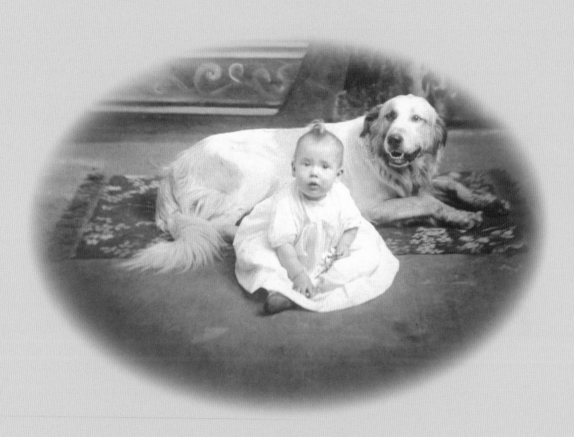

CIRCA 1904—1910

About the Photographs

The earliest images in this collection are professional studio portraits, as the technology for amateurs to take photos easily and inexpensively did not yet exist. Many studios embossed their name and location on the front of the photo's card stock mounting, and/or printed an advertisement for their services on the back. The studio location has been included whenever it is provided, as this often is the only information about the sitters that is available to us. In most cases, it's reasonable to assume the children probably lived near the studio, thus the locale—whether in Fresno, California, Elgin, Texas, or Aachen, Germany—gives important context to their lives.

Of course, it shouldn't be assumed that the children necessarily lived in the city or town imprinted on an image. As camera equipment became less unwieldy and more portable, photographers could leave their studios and travel in search of new business, while continuing to identify their studio's location on each print for customers or visitors back home. For those interested in further research into specific photographers, the names of all the studios/photographers appearing in these pages are listed on page 116.

The other type of photograph featured in this collection is the photo postcard, prevalent from the turn of the twentieth century into the 1920s. Cameras that took postcard-sized images were available to amateurs as well as professionals, with the

advantage that any number of cards with preprinted backs could be made inexpensively. Some of the examples in this collection are probably duplicates and were never sent. But among the cards that were mailed, the postmark on the back fortunately provides both a city and an indisputable date, although time and rough handling have made some examples impossible to read. (The postcard from Oregon, on page 53, was mailed from someplace with the first three letters WAL. Unfortunately, the rest of the name is not there, and since there are several locations in Oregon beginning with those three letters, we will never know where poor Dell was struggling to get by with her bad arm)

As might be expected, the messages on the back range from terse and cryptic to lengthy and meandering accounts of weather conditions and family health updates. Many of these messages have been reprinted in the captions.

Whenever a specific date was handwritten on the back of a photo, it has been incorporated into the caption. Otherwise, an approximate date, or a range of dates, has been provided. These dates are courtesy of two staff members at the Oakland Museum of California: Inez Brooks-Myers, in the History Department, and Drew Heath Johnson, Curator of Photography. I am incredibly grateful and indebted to them both for generously sharing their expertise and giving the photographs an added layer of depth.

At Ten Speed Press, thank you to my publisher Phil Wood and my editor Veronica Randall for your wonderful enthusiasm. And special thanks to designer Catherine Jacobes, who was there from the very beginning.

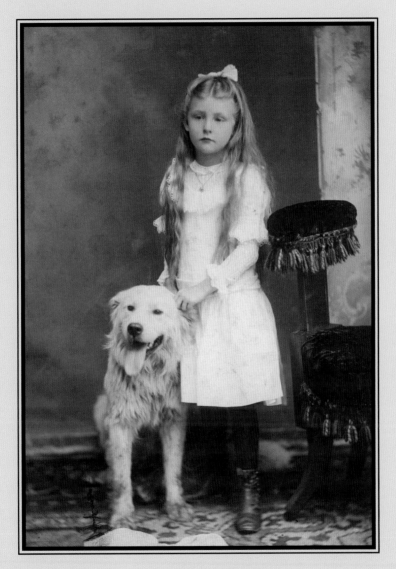

"Carrie Martha Bradford
6 years 12th September 1902
Judge the dog"

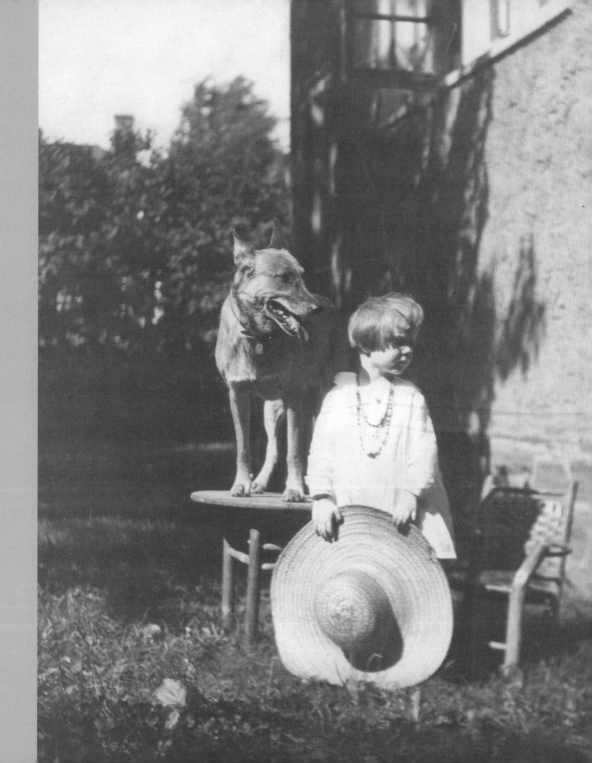

"Bryn Mawr
July 1920"

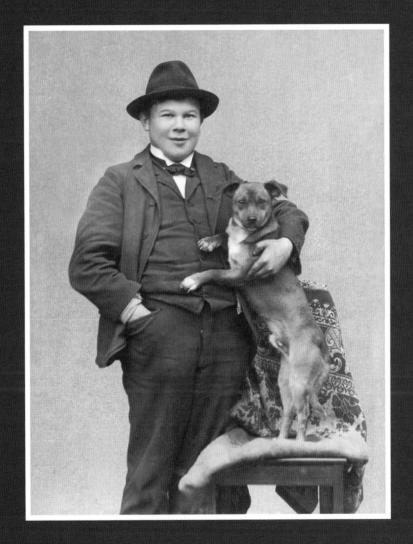

CIRCA 1885

Photographer's studio located in Vienna, Austria

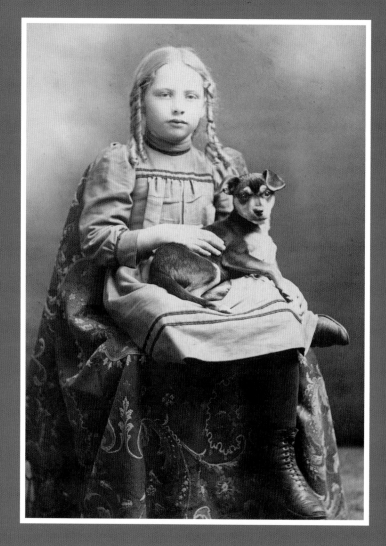

CIRCA 1900

Photographer's studio located in Evansville, Indiana

This puppy looks like a Manchester terrier, referred to in Victorian times as the "gentleman's terrier."

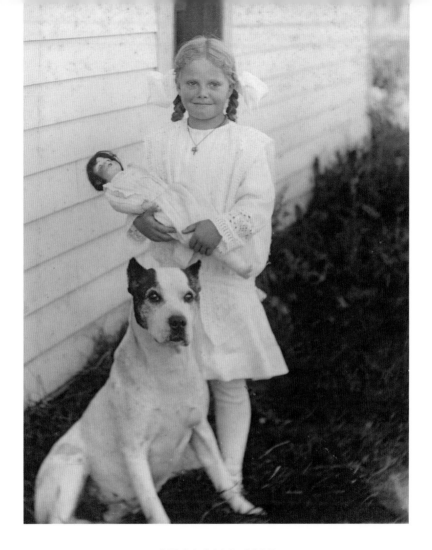

CIRCA 1912—1915

This dog strongly resembles today's American bulldog, a breed that did not officially exist until the 1970s, though there is evidence that these dogs were present throughout rural areas of the South during the first half of the 1900s. His features are similar to those of early bulldogs, like those seen in numerous eighteenth- and nineteenth-century paintings and prints—the ancestors of most of today's bulldog breeds. In fact, the American bulldog was developed specifically to bring back the attributes of the classic working bulldog that some fanciers claim were lost during the twentieth century.

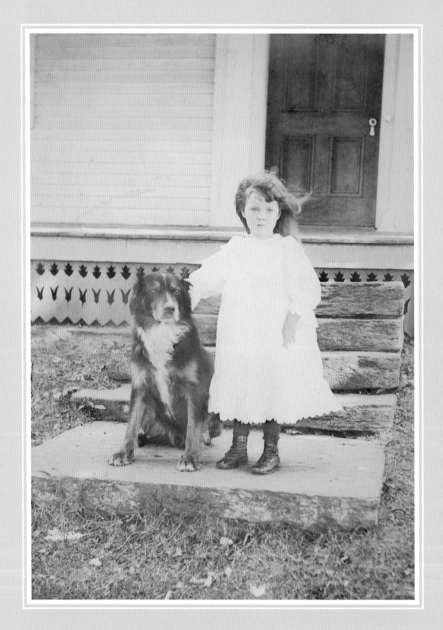

CIRCA 1895

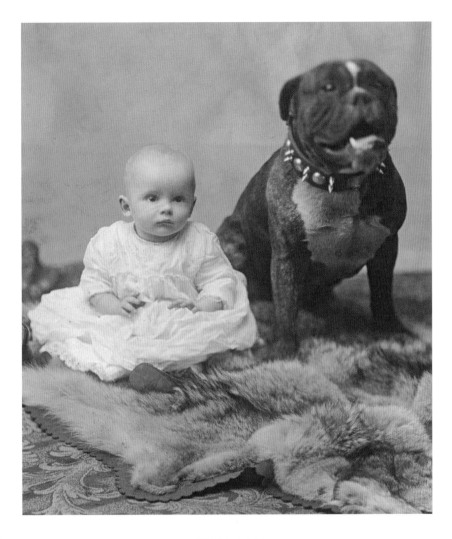

CIRCA 1910

At the turn of the twentieth century, pit bull-type dogs were immensely popular
companion dogs and never considered untrustworthy around small children.
In fact, the breed standard for American pit bulls, written in 1898, observes
that these dogs "have always been noted for their love of children."

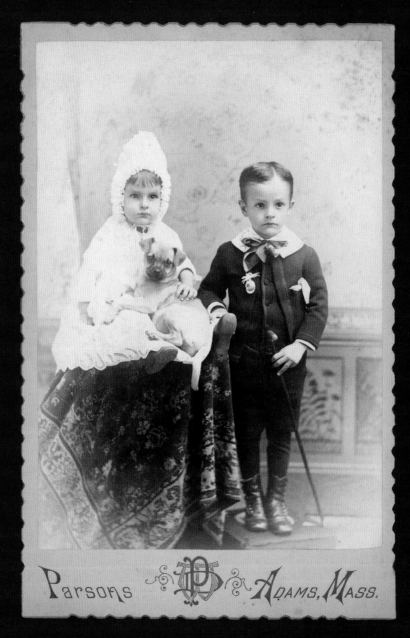

Parsons P&S Adams, Mass.

CIRCA 1890

9

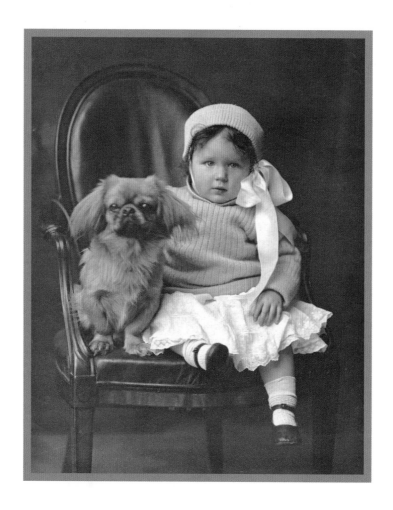

Photographer's studio located in Harrogate, England

"Dear Mrs. Keizer, What do you think of my little cherub? Kathleen is just 18 months."

Kathleen's dog is a Pekingese—a breed that for thousands of years was unknown outside of China until 1860, when British soldiers brought several of the dogs home to England with them. Queen Victoria received one as a gift and the breed subsequently enjoyed immediate popularity.

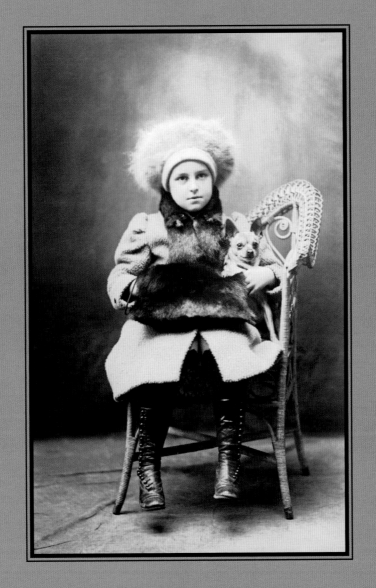

CIRCA 1910—1915

"Frances and her dog Fritz. Frances is now 9 years old."

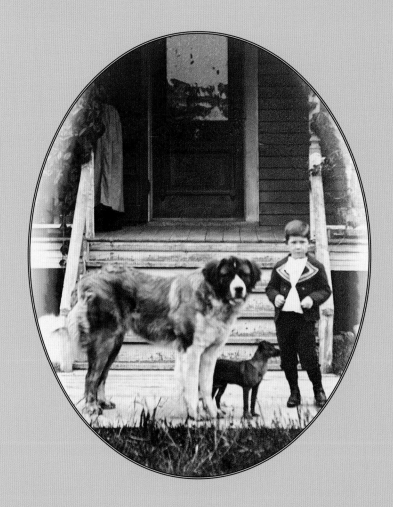

CIRCA 1905

From *The Book of Dogs,* published in 1919:

"The deep personal affection with which St. Bernard owners invariably invest their companions is the best expression of the character of these great, dignified and rather somber dogs, which inspire no fear, even in little children, and which return the stranger's gaze with a look of calm, steady, and indulgent tolerance, and endure the advances of the unacquainted with a patience and dignity that speak worlds for their gracious and enduring disposition."

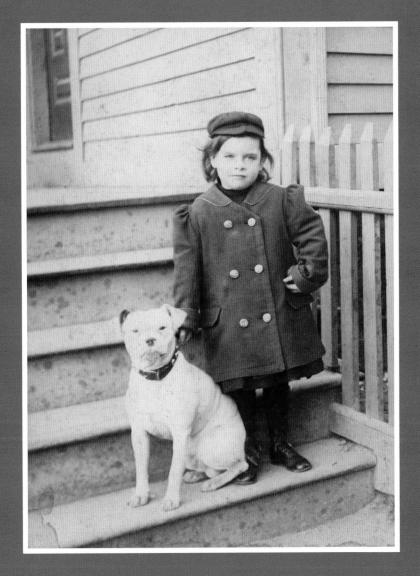

The reverse side of this portrait assures customers that "the negative can be reduced to the size of the smallest Locket or enlarged to Life Size."

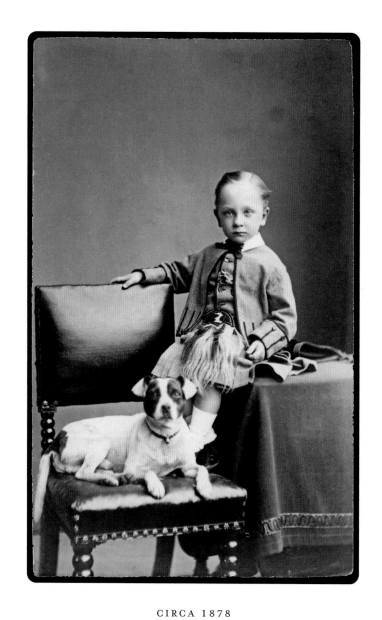

CIRCA 1878

Photographer's studios located in Reading and Basingstoke, England

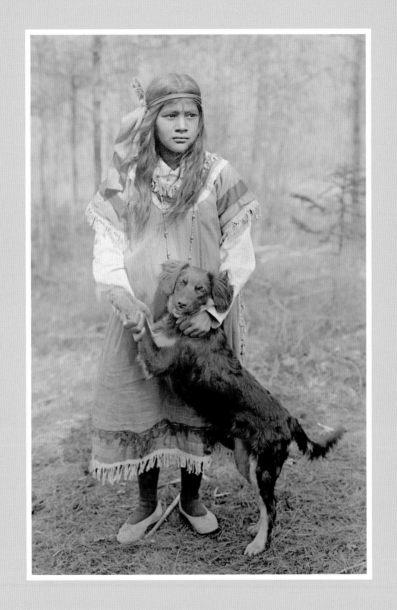

CIRCA 1918—1925

"Elizabeth Andrews, Indian Island, Old Town, Maine"

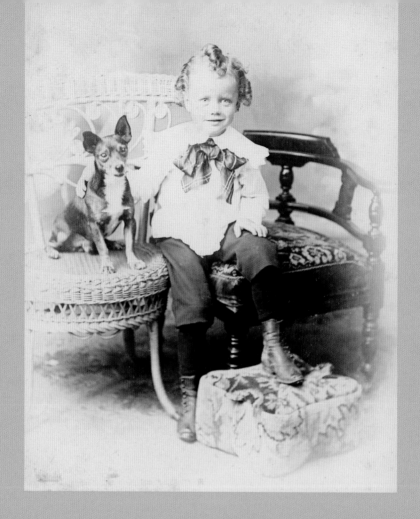

Photographer's studio located in Michigan

In the Victorian era, the term "rat terrier" referred not to one specific breed but to any number of terrier-type purebreds or mixes (including English toy terriers, Manchester terriers, American rat terriers, and miniature pinschers) that were bred specifically for rodent control. "Ratting," a gruesome pastime in which people bet on how many rats a dog could kill in a specified period of time, was a widespread fad at this time. Hundreds of rats were placed in a pit with the dog, who would snatch them up, quickly break their necks, drop them to the ground, and immediately pick up one or two more without ever breaking rhythm.

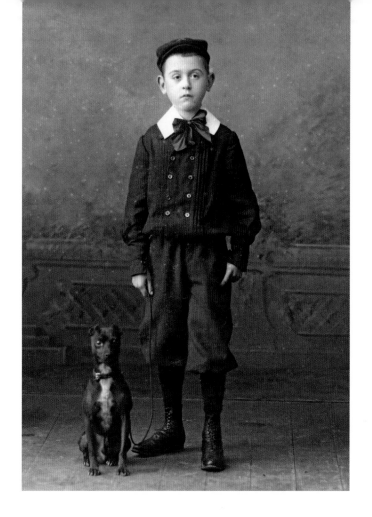

Photographer's studio located in Wiesdorf [now called Leverkusen], Germany

From *Breaking & Training Dogs: Being Concise Directions for the Proper Education of Dogs, Both for the Field and for Companions,* published in 1903:

"The days of the rat-pit are over....I do not think there is very much, if any, regret felt by those of us who in green youth witnessed such things; moreover, terriers of the right sort—not necessarily either the show ring or the drawing-room sort—are just as keen and good vermin destroyers as ever; and it must, therefore, be admitted that rat killing contests were never necessary to the education and development of the dog's useful qualities."

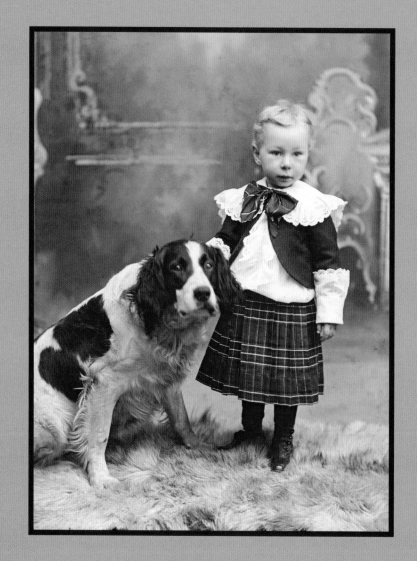

CIRCA 1890

Photographer's studios located in Jewett City and Moosup, Connecticut

This little boy poses with his English springer spaniel, so named because they "spring" game birds from their cover.

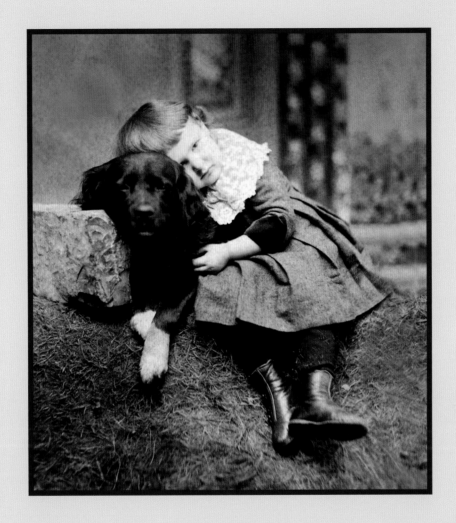

CIRCA 1888—1890

"David"

Left and above: Boys younger than five years old routinely wore dresses and skirts from the 1700s clear into the 1920s. With their bows, elaborate ruffles, and lace trim, the outfits look to our eyes to be identical to girls' attire, however boys' and girls' dresses were actually distinct to viewers of the time.

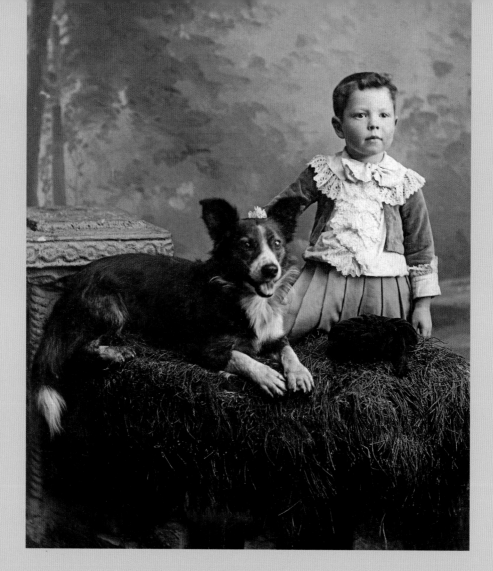

CIRCA 1890

Photographer's studios located in Minerva, Carrollton, and Malvern, Ohio

Perhaps the earliest reference to a border collie-type dog appears in Johannes Caius's book *Of Englishe Dogges*, written in 1576, in which he described a medium-sized "shepherd's dogge" that would "bringeth the straying sheep" upon "hearing his masters voyce, or at the wagging and whisteling in his fist, or at his shrill hissing."

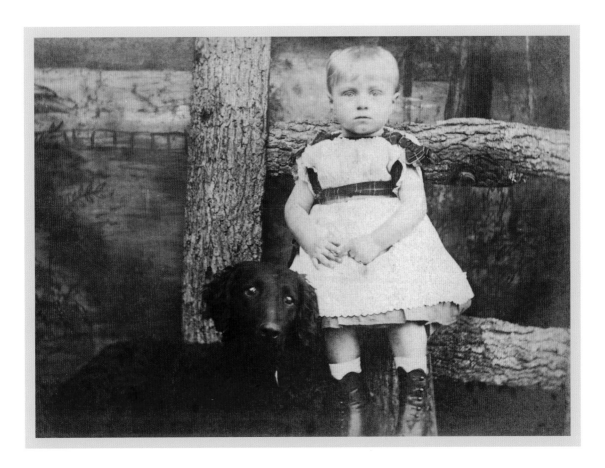

CIRCA 1882

The curly-coated retriever, which this dog strongly resembles despite her rather small size, is relatively uncommon today. This breed was once the most widely used of the gun dogs, but after the arrival of golden retrievers the curly-coated fell out of fashion.

From *Retrievers and Retrieving*, published in 1905:
"The Curly-Coated Retriever, whose first public appearance was at the Birmingham Dog Show in 1850, may rank as the oldest recognized variety [of retriever], but of late years he has practically been entirely relegated to the Show Ring, and seldom appears at our Shoots or Trials."

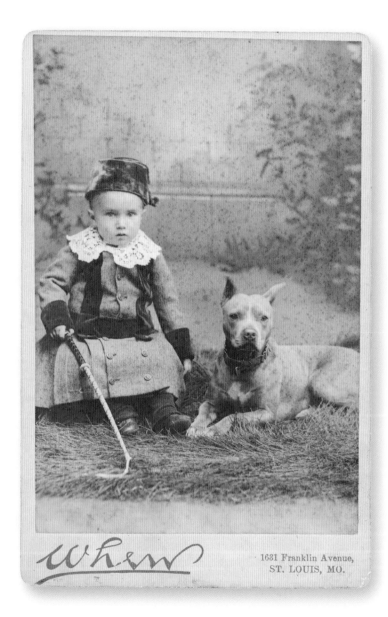

When

1631 Franklin Avenue,
ST. LOUIS, MO.

The whimsical name of this St. Louis studio, "When" (possibly a reference to "remember when"), and the pink color of the mount are quite uncharacteristic features for 1888.

The dog certainly fits all the attributes of the breed listed on page 54: she appears to be faithful and reliable, and she is undeniably "exceedingly handsome to look at."

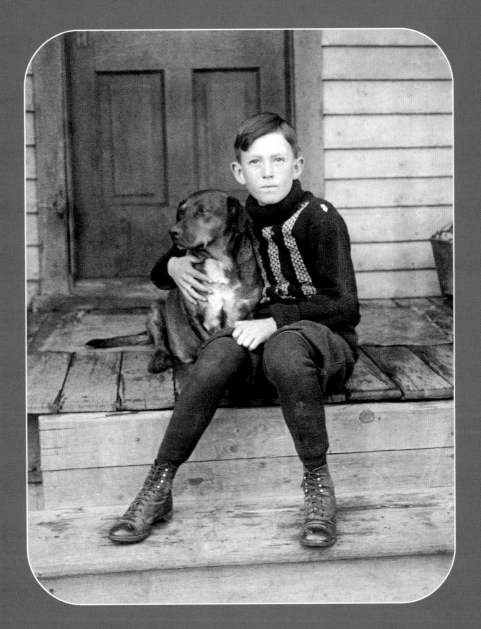

CIRCA 1908

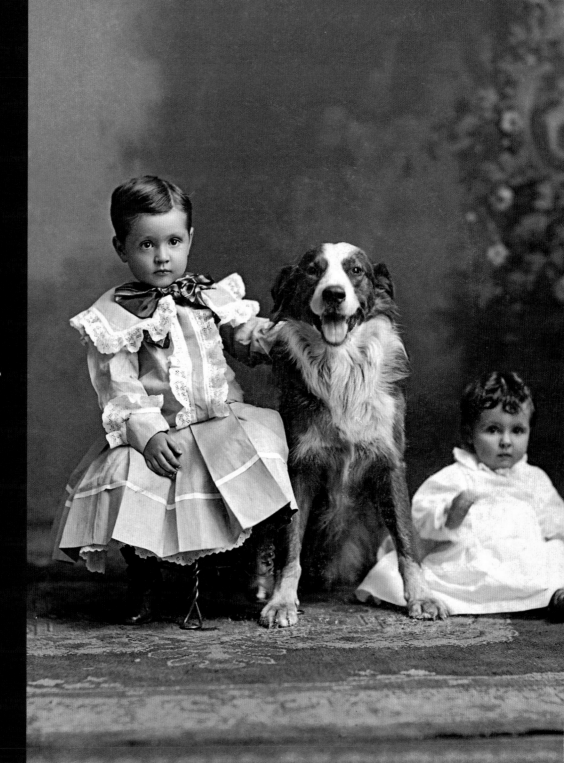

CIRCA 1895

Photographer's studio
located in Luverne,
Minnesota

With young boys wearing frilly dresses, how can the gender of an unknown child be determined? The answer is in the hair: as a rule, a girl's hair was parted in the middle and a boy's was parted on the side. Complicating the matter is the fact that thick bangs were seen on both girls and boys, but at least on the issue of parts the rules were clear.

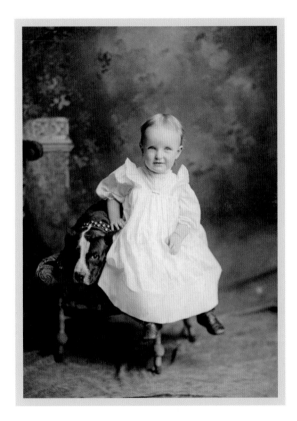

CIRCA 1900

Photographer's studio located in Lowell, Massachusetts

Above: The center part confirms that this is a little girl with her pit bull terrier.

Left: His blouse and skirt are wonderfully opulent, but the definite side part reveals his gender.

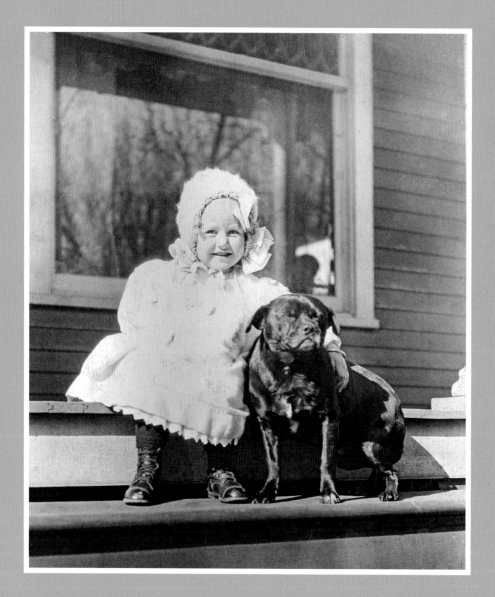

"What do you think of Nedra and Mae?"

Postmarked April 14, 1911, from Maroa, Illinois

From *Working Terriers: Their Management, Training and Work, Etc.*, published in 1919:

"There is no doubt that the Jack Russell type of working terrier is still the best. Most of my readers will not need reminding who Jack Russell was. Never was there a more enthusiastic or skillful master of foxhounds amongst the Church of England clergy, nor a better judge of both a good dog and a good horse. It is interesting to recall how Russell came by the first of the terriers that help to keep his name fresh in our memories. When an undergraduate at Oxford, he chanced one morning to meet a milkman with a terrier—such an animal, we are told, as Russell hitherto had only seen in his dreams. He stopped the man and bought the dog. Her name was Trump.... She was the foundation-stone on which Russell built up the whole of his strain of workers."

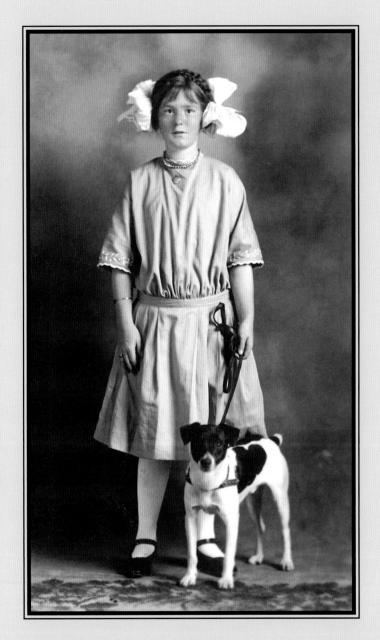

CIRCA 1915

27

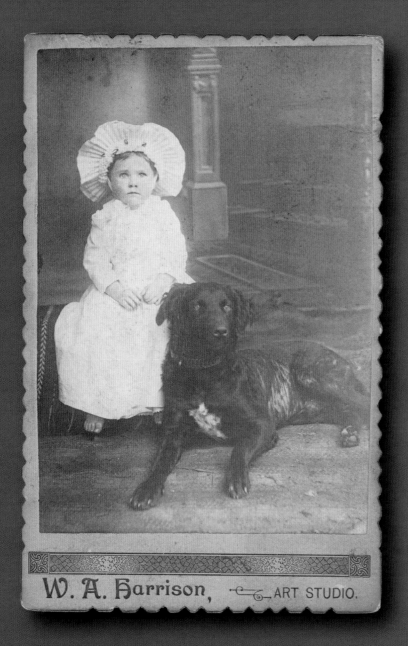

W. A. Harrison, ART STUDIO.

This portrait is noteworthy because nineteenth-century children rarely came to a professional photographer's studio in bare feet.

CIRCA 1893

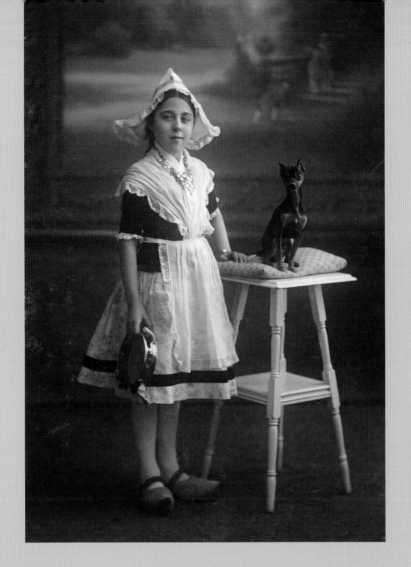

CIRCA 1900

Photographer's studio located in Aachen, Germany

This diminutive little fellow is a miniature pinscher. The photograph captures the breed at a time and place when it had become smaller and more frail-looking than the standard today. At the end of the 1800s in Germany the fashion was to breed these pinschers as miniscule as possible, even to the detriment of the dogs' health.

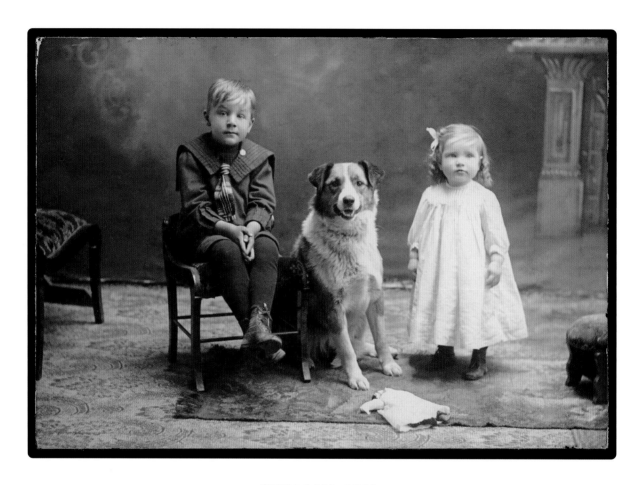

CIRCA 1890—1900

Photographer's studio located in Dallas, Wisconsin

**"Harold, age 5
Ida, age 17 months"**

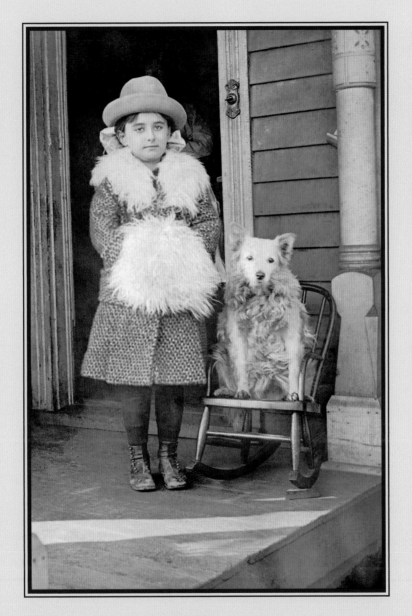

CIRCA 1904—1918

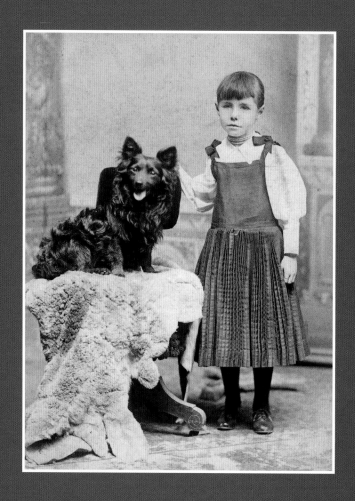

From the studio of Mrs. K. Bryant, located in Indianapolis, Indiana

Female professional photographers in the late 1800s (there were a surprising number) often made a point of announcing their gender by printing their full names on their photo mounts, whereas men tended to use initials or only a last name. Today, these photographs are sought after by collectors with a special interest in nineteenth-century female entrepreneurs.

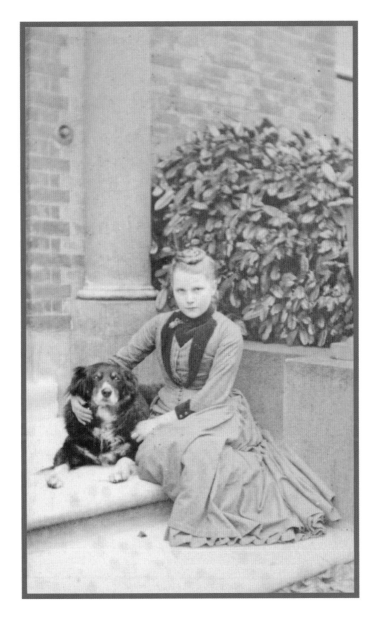

CIRCA 1875

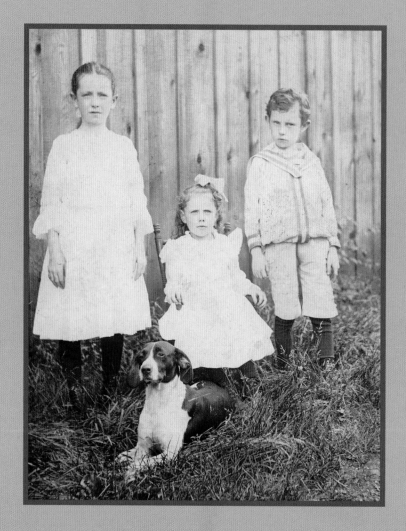

Photographer's studio located in New York, New York

Originally, pointers were used in tandem with coursing hounds such as greyhounds, the two types playing completely different roles. After the pointer located the hare and held it at a point, the greyhounds were let loose for the capture.

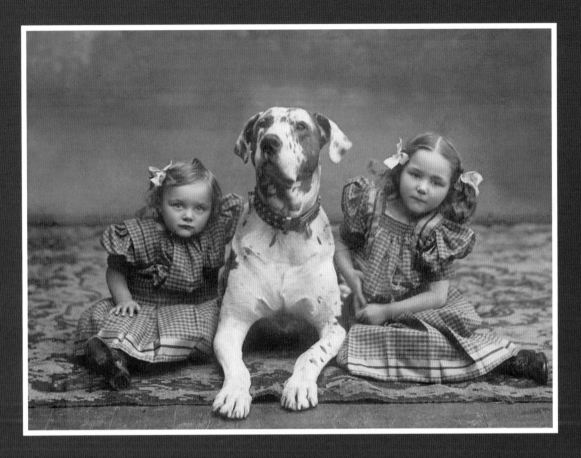

Photographer's studio located in Copenhagen, Denmark

Great Danes, also known as Deutsche dogges, are descended from the boarhounds that are often depicted in medieval artwork bringing down the large boars that once roamed European forests. It was said that these dogs had the ability to see and guard against spirits. The Great Dane, which developed from the German boarhound in the 1800s, was selected as the national dog of Germany in 1876.

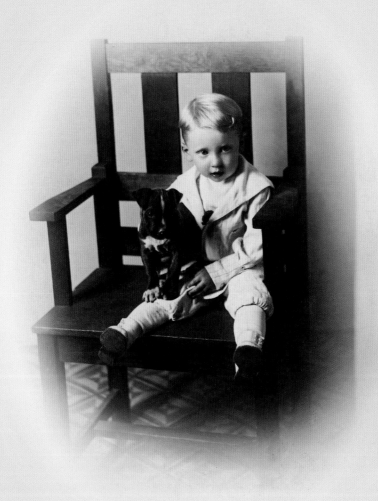

"To Daddy,
Elbert E. Ross. Age 3 years, September 25, 1914.
Taken in June, 1914."

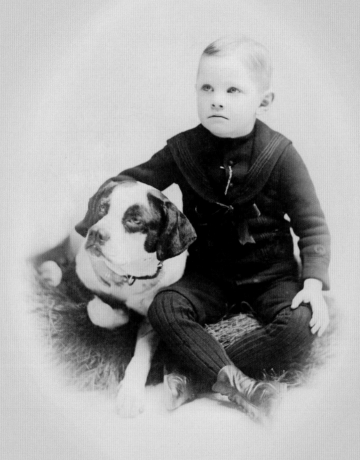

CIRCA 1895

Photographer's studio located in Portland, Oregon

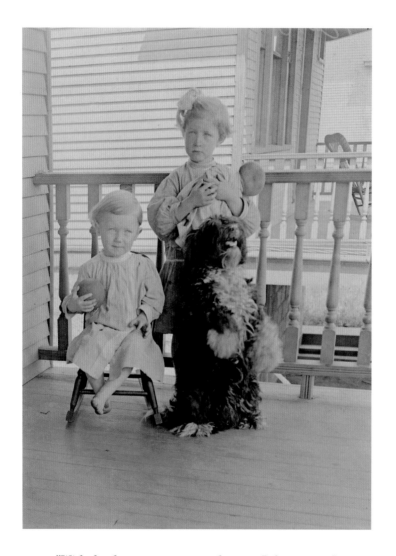

From *Breaking & Training Dogs: Being Concise Directions for the Proper Education of Dogs, Both for the Field and for Companions,* published in 1903:

"And now for the usual 'sit up and beg' lesson. Put some broken biscuit or sugar in your pocket, and take your pupil to the corner of the room, and set him up with his back leaning in the angle....Tempt him by holding something nice just above his nose, and perhaps helping him up a little with the other hand. As soon as he sits up fairly of his own accord in the corner, practice him against a flat wall, and next against the leg of the table or your chair, at meal times, also on the seat of a chair that has a straightish back. If he is taught thus regularly for a few minutes daily, he will soon find his centre of gravity, and sit up with considerable aplomb."

"With the thermometer at 90 degrees, July 30 1909"

Postmarked from Chicago

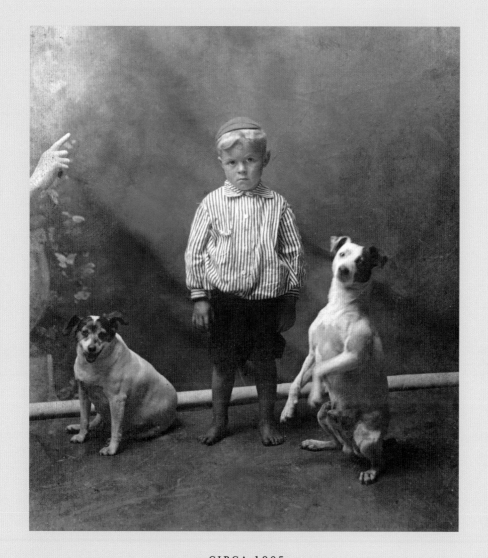

CIRCA 1905

"Burgettstown, Pennsylvania"

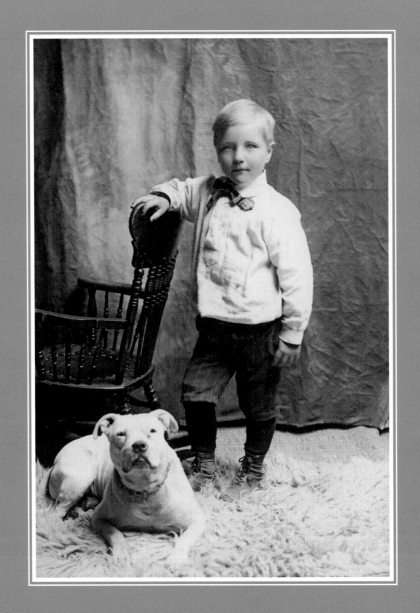

CIRCA 1900

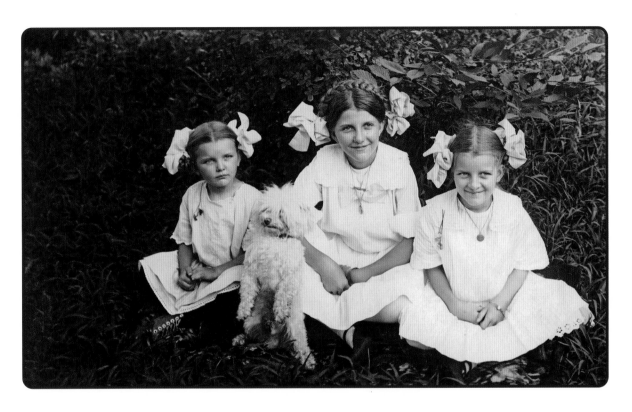

"Flora was 11 in November. Nina was 8 in March. Helena was 4 in October. Taken July, 1912."

Toy poodles were immensely popular as performers in circuses, carnivals, and fairs throughout the seventeenth, eighteenth, and nineteenth centuries. Whether he was part of a traveling dog troupe or the sole attraction of an itinerant entertainer, the poodle's extroverted personality made him a natural for the spotlight. Standard poodles (see page 103) were developed first; the toys were developed by crossing smaller-than-usual standards with other toy dogs.

CIRCA 1915

"Son of J. Davis, Texarkana"

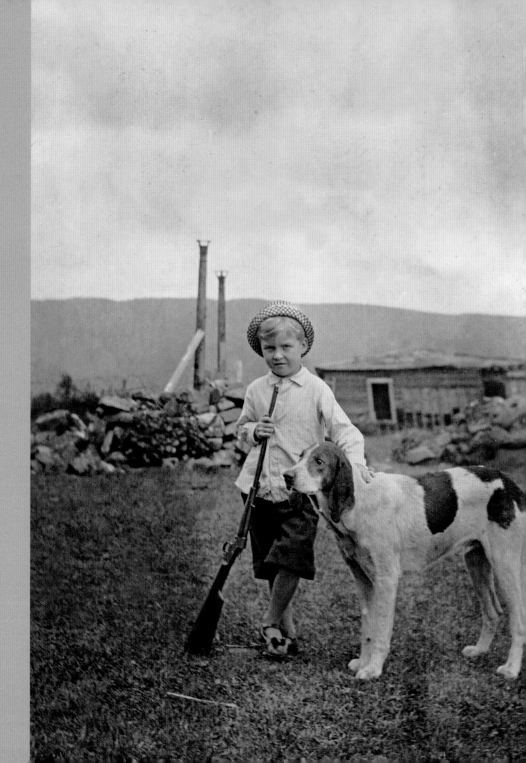

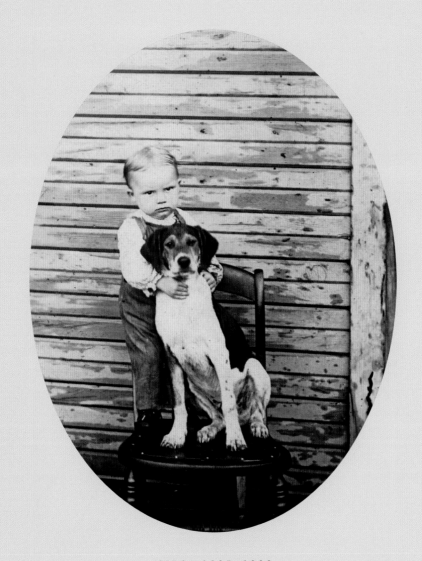

CIRCA 1895—1900

Left and above: While most hunting dogs (such as the numerous varieties of pointers, retrievers, and spaniels) have nineteenth-century origins, hounds date back to the Middle Ages and earlier—they were among the first dogs that were bred and trained to help us hunt.

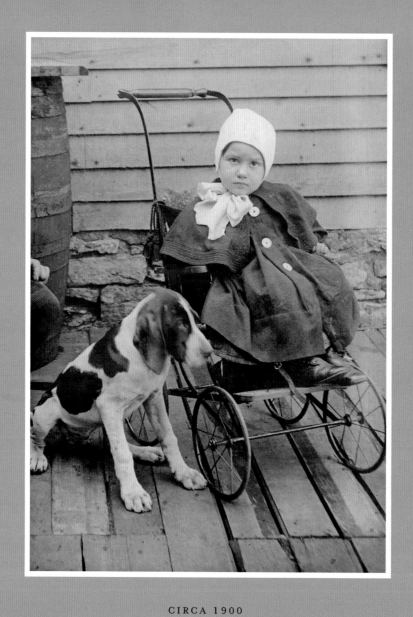

CIRCA 1900

Photographer's studio located in Minneapolis, Minnesota

Right: This dog strongly resembles a French Pyrenees hound, and given that the photo is not from the United States but from Spain, that breed is a very likely possibility. France was traditionally a hotbed for hounds, and to this day there are far more hound breeds in France than any other country (over twenty-five distinct varieties, compared to fewer than a dozen in other nations).

Left: The quintessential hound dog pup. She hasn't yet grown into her long ears (that will help capture and hold a scent to her nose) or long legs (that will carry her over rough terrain).

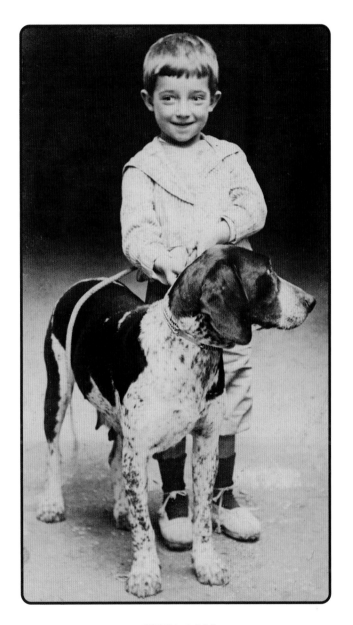

CIRCA 1900

45

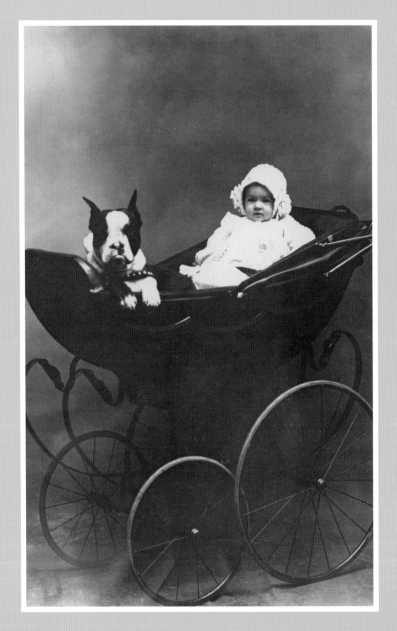

CIRCA 1905—1910

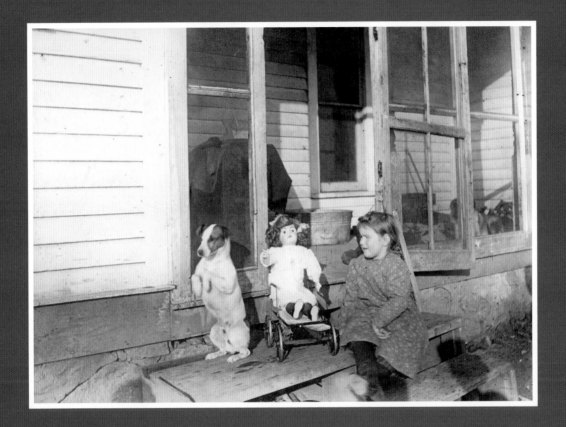

CIRCA 1905—1910

This photo postcard was never mailed, although someone
started to write a message on the back:

**"Ciss & her doll & Poacher.
Don't say anything about the things on the porch."**

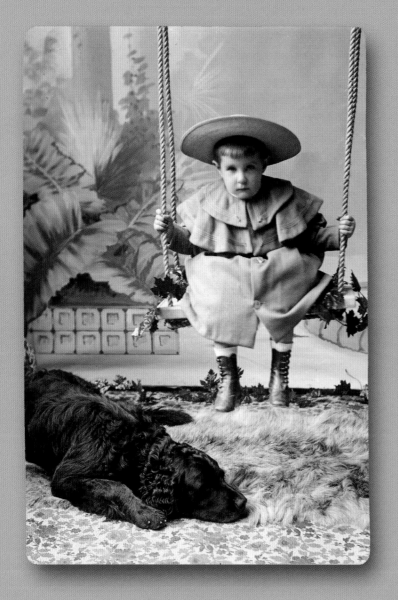

Today, most people think of retrievers in terms of specific breeds (such as Labradors or Chesapeakes), but in the nineteenth century a retriever was defined as any dog that excelled at retrieving—including mixed breeds. In fact, hunters looking for the best working retrievers were frequently encouraged to seek out Newfoundland crosses: "If we search through the sporting books of the last century, we read of various cross-breeds recommended as making good Retrievers. One writer advocates a cross between Setter and Newfoundland, another points out the advantages of a strong Spaniel and Newfoundland." (From *Retrievers and Retrieving*, published in 1905).

The sleepy dog in this photo could easily be such a Newfoundland mix.

CIRCA 1890—1895

Photographer's studio located in Shepton Mallet, England

The reverse side of the card on which professional photographic prints typically were mounted evolved over time. The earliest were blank, while the 1860s saw very simple imprints. These became more and more ornate until, after 1872, the fashion was for a large, elaborate design that covered most of the reverse side of the card and advertised the studio's services. Cherubic, naked, winged "photographers" were a recurring motif.

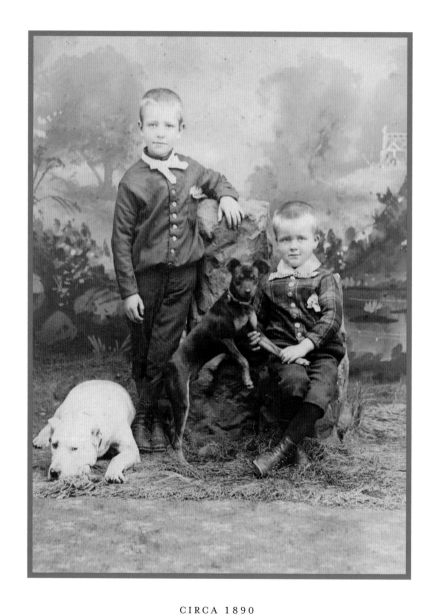

CIRCA 1890

Photographer's studio located in Milwaukee, Wisconsin

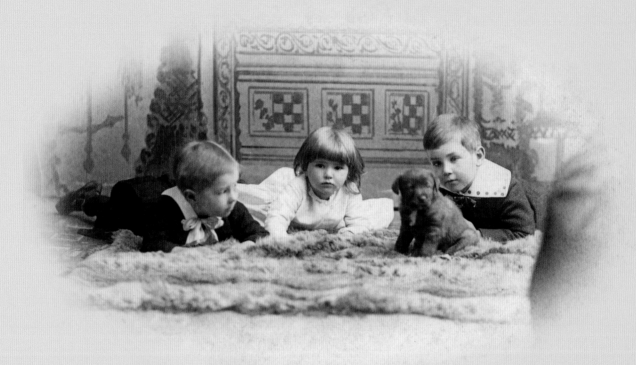

CIRCA 1890

Photographer's studio located in Kearny, Nebraska

This puppy's-eye-level perspective is very unusual in nineteenth-century photography.
The name of the boy on the left is illegible; the other children are Sarah and Ed.

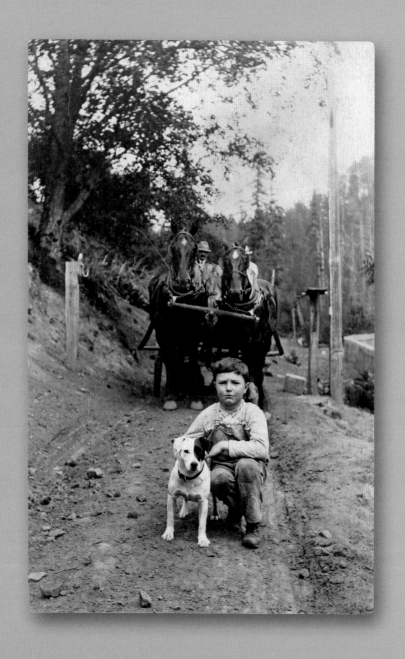

"Dear sister, I read your letter and glad to hear from you. We are all usually well. I can get around fairly well, and I use my arm better than I could. Ada and Theron been to visit the folks in Eugene & Springfield. Gone a week, found them all about as well as usual. I had a girl to stay with me, Will was here to. He was working in his [?] done now. Very dry here. Need rain but don't want the lightening. Sorry you felt so bad, hope you are all right now. This is a picture of Theron and his dog Jack. Picture was taken by a young man who stepped off the stage for a drink. See the stage mail post on the corner of the yard fence. The man sent Theron half a dozen for nothing. Cheap enough. Love as ever, Dell."

Postmarked July 28, 1910,
from Oregon

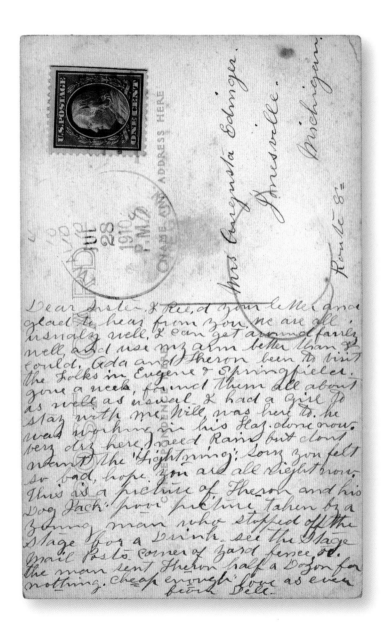

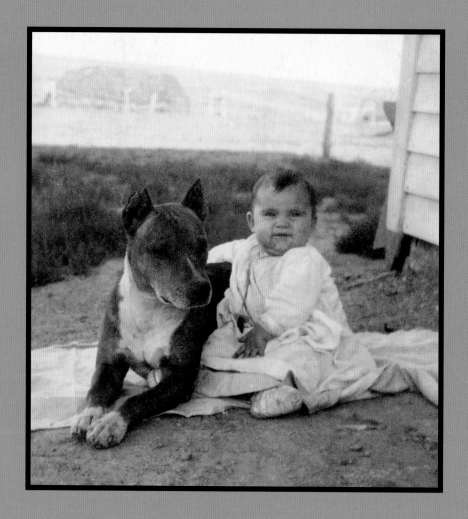

CIRCA 1910

From *The Sporting Pit Bull Terrier*, published in 1910:

"These dogs make remarkably faithful and reliable companions and watch dogs; they are exceedingly handsome to look at, of affectionate disposition, easily taught many useful and pleasing stunts, and delight in the extermination of all sorts of objectionable vermin."

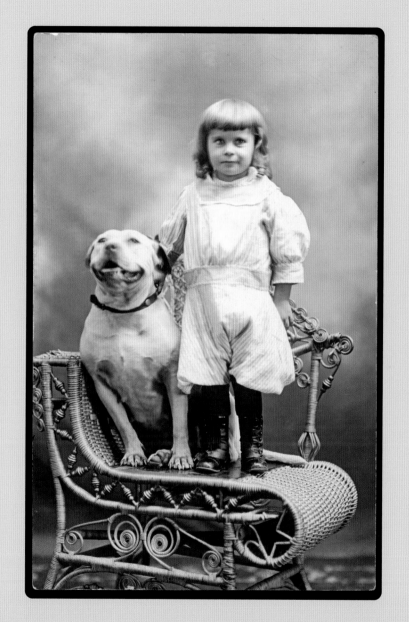

CIRCA 1908—1910

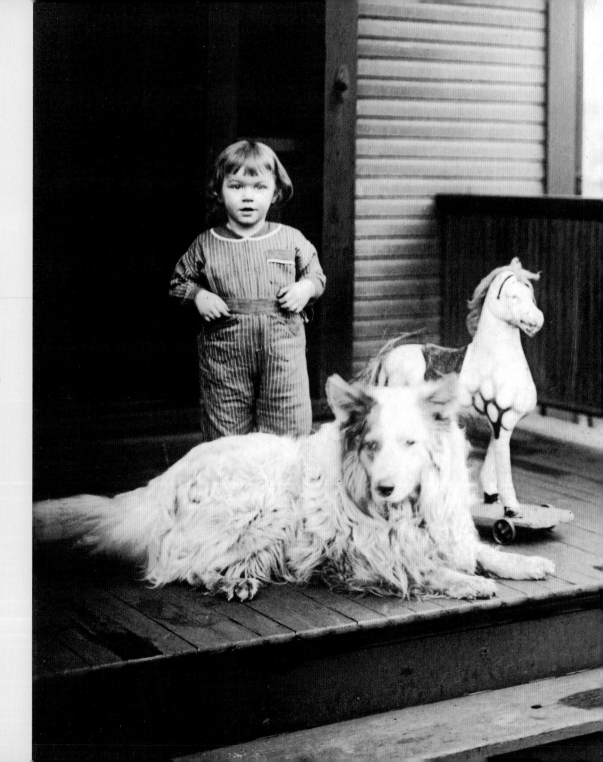

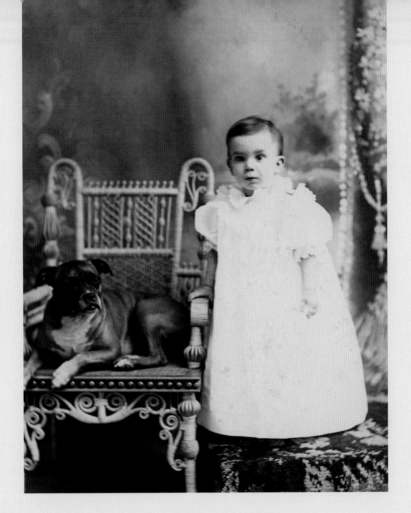

Photographer's studio located in Rochester, Indiana

Boxers did not exist until 1895, when the offspring of an English bulldog and a mastiff mix became the "founding fathers" of a new German breed. (The German Boxer Club was formed a year later.) This dog certainly appears to be a purebred boxer, so the date of the photo raises questions: was the child perhaps a recent immigrant from Germany, his family bringing along with them one of the first boxers? Or is this dog an American mixed breed with a similar mastiff/bulldog ancestry, whose striking resemblance to a boxer is just a coincidence?

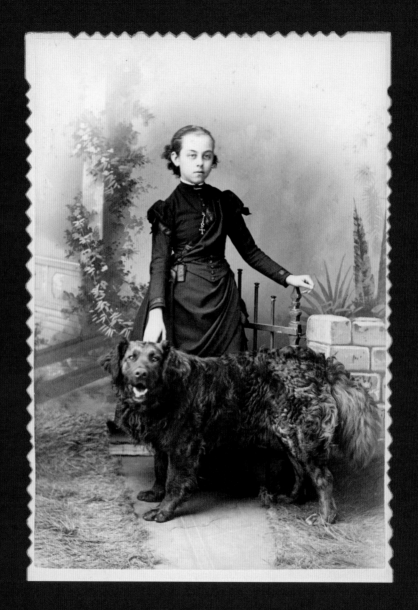

CIRCA 1888–1890

Photographer's studio located in Hartford, Connecticut

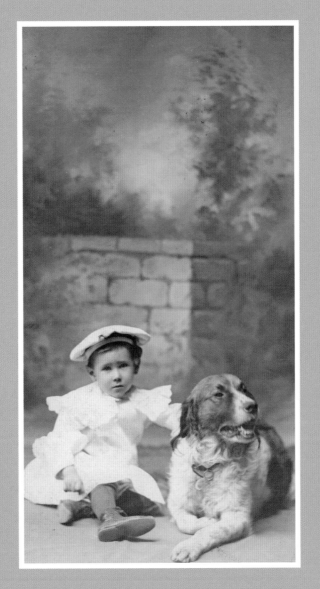

Photographer's studio located in Dubuque, Iowa

"George T. Deckert. Age 3 years. 1900."

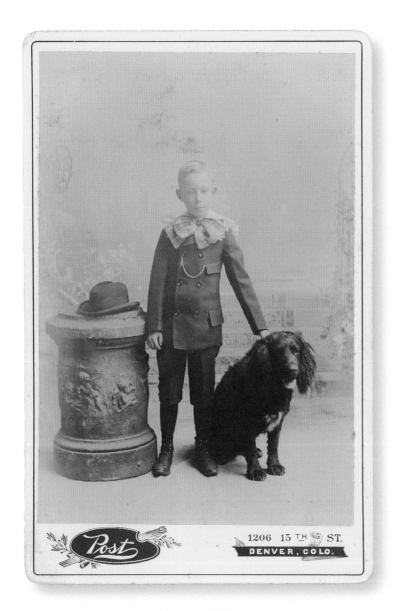

From *Breaking & Training Dogs: Being Concise Directions for the Proper Education of Dogs, Both for the Field and for Companions,* published in 1903:

"Spaniels will be found to puzzle out a trail much more closely than the retriever...they are nearer to their work, and do not get so excited or hurried about the business as a young retriever does; and, if they were only powerful enough to lift and carry a hare or pheasant well out of the mud, they might with advantage supplant their big brothers."

CIRCA 1890

Photographer's studio located in Denver, Colorado

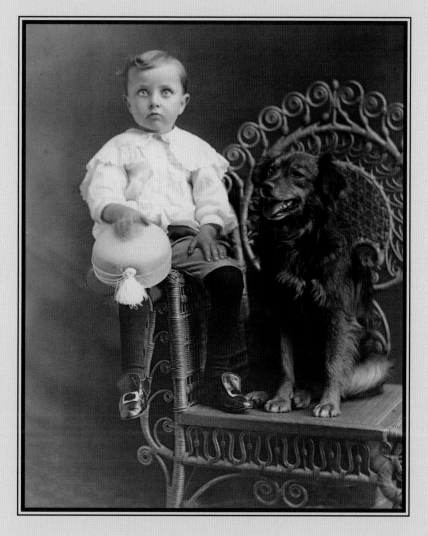

CIRCA 1895

Left and above: Somewhere between the ages of five to seven, boys were finally "breeched"—taken out of dresses and put into short pants. This did not, however, put an end to ornate collars and lace-trimmed blouses!

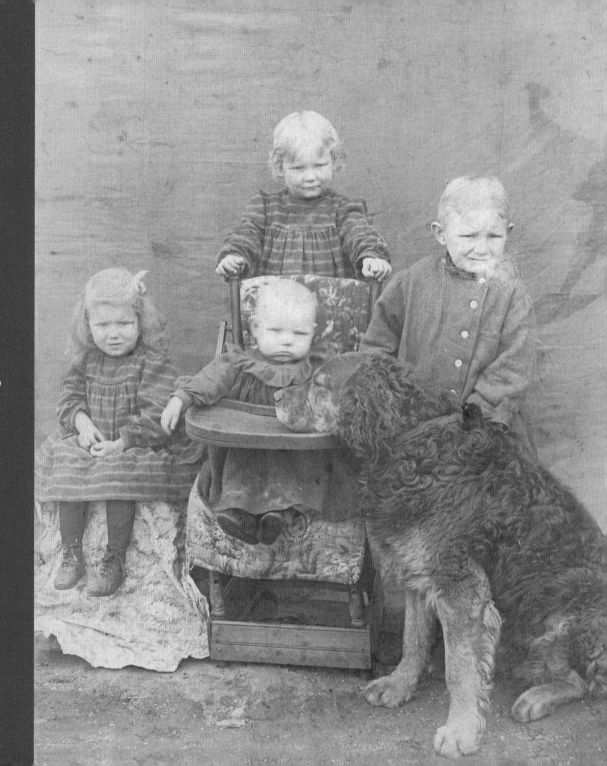

CIRCA 1900

Itinerant photographers traveled into rural areas to offer their services to those who would otherwise never have the opportunity for a portrait. Two clues here indicate that this family posed at home for an itinerant photographer: the backdrop appears to be a sheet hung outdoors, and the highchair isn't of the quality one would expect to find in a professional studio; it was probably used and passed down to each of the children.

F. J. WEBER & BRO.,

Photographers,

ERIE, - - PENN.

Portraits, Views, Machines, Models, Stereoscopic Views, Copying and all kinds of Photographing done.
Pictures finished in Ink, Crayon, Oil or Water Colors.
All Negatives numbered and preserved. Additional copies of this or all pictures at reduced rates.
Constantly on hand an assortment of Oval and Square Frames.
All orders by mail or otherwise, promptly attended to.
Do not trust your pictures out of town, to be copied, to traveling photograph bummers, who make great promises and generally deliver very poor work.

Apparently, itinerant photographers weren't always well respected. One photographer from Pennsylvania, circa 1880, printed an ad for his studio on the back of his photos and couldn't resist taking a jab at those "bummers."

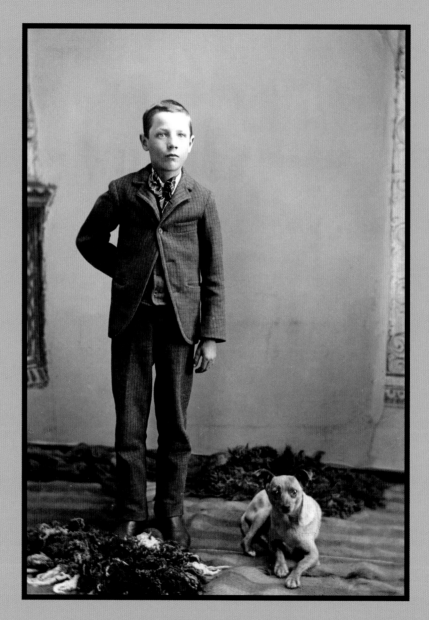

"Mrs. Burgus's cousin, 1893"

A dog for each brother? These fellows appear to be a Bernese mountain dog (left) and a mastiff (with very muddy paws). Both are centuries-old breeds that were fairly common in Europe but less so in the United States. The Bernese actually did not go by that name until 1908; previously he enjoyed a variety of colorfully descriptive names—such as "cheese factory dog," thanks to frequent employment pulling dairy carts.

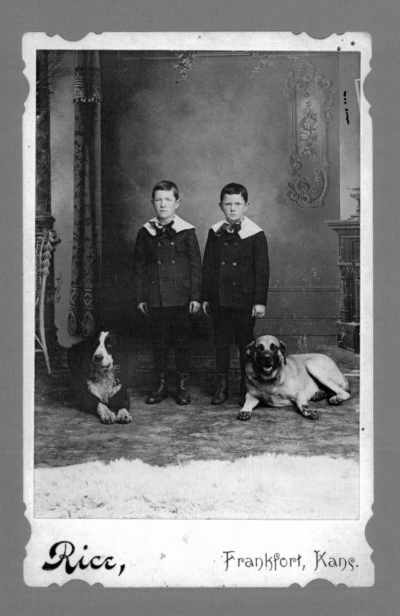

Rice, Frankfort, Kans.

CIRCA 1890

Photographer's studio located in Frankfort, Kansas

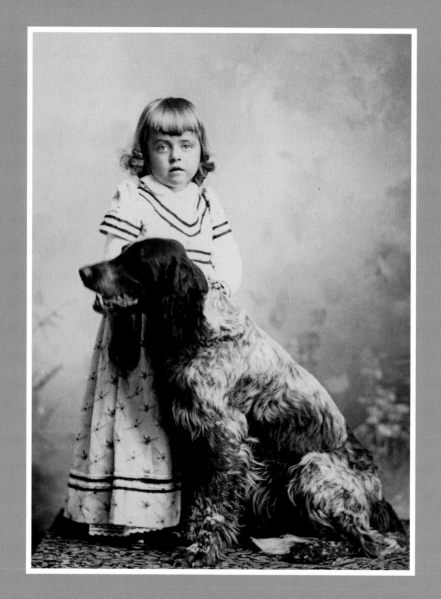

Photographer's studio located in Russell, Kansas

From *Breaking & Training Dogs: Being Concise Directions for the Proper Education of Dogs, Both for the Field and for Companions,* published in 1903:

"As regards a *choice* between pointers and setters it will very much depend upon what style of country is going to be worked. For the moors, and for hard work in a cold, rough, or wet country, undoubtedly the setter is the dog for the situation; while for the more *refined* work of an English partridge manor, probably a pointer will be the most suitable."

Left: A setter, perfect for work on the moors.

Right: A pointer, good for your English partridge manor.

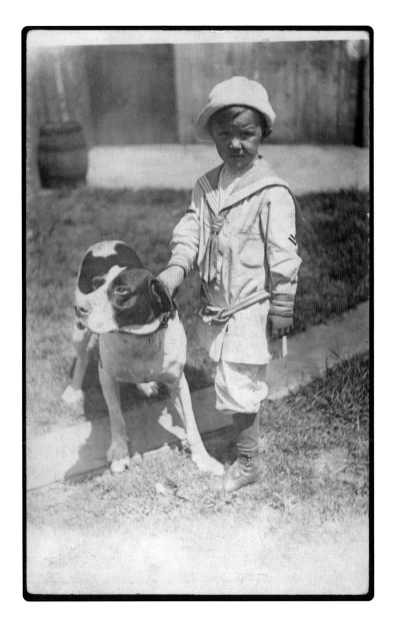

CIRCA 1915

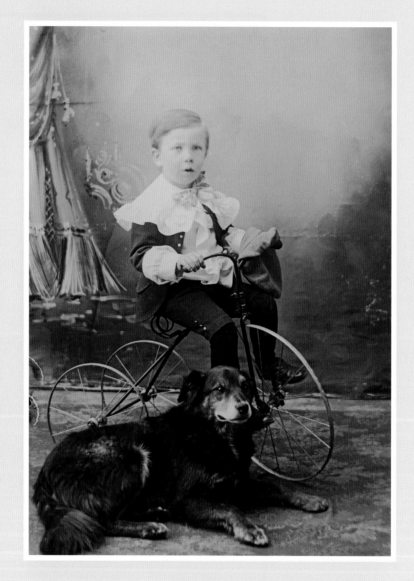

CIRCA 1890

Photographer's studio located in Traverse City, Michigan

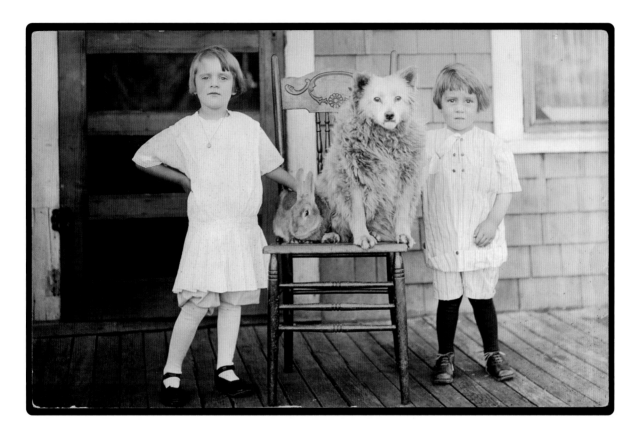

CIRCA 1910—1914

"Jessie & Buzz"

The ease with which this bunny sits next to his shaggy friend suggests he was a household pet who played with Jessie and Buzz frequently. Pet rabbits were fairly uncommon in the 1800s, but interest in them dramatically increased after the turn of the century. The American Rabbit Breeders Association (the rabbits' version of the American Kennel Club) was formed in 1910, close to the year this photo was taken.

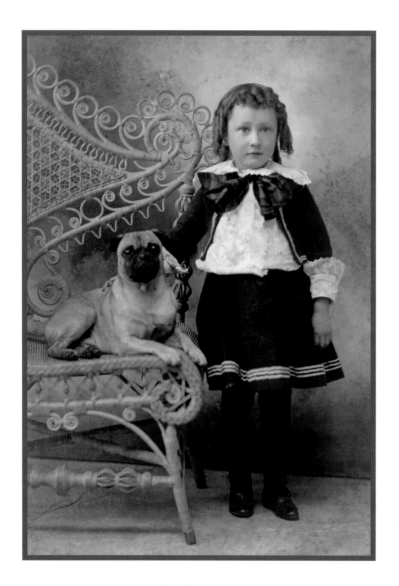

Throughout the 1880s, pugs were all the rage. They were accepted into the American Kennel Club in 1885, and enjoyed roughly another decade of celebrity before fading completely from the spotlight. Today, pugs are back—and currently experiencing a massive resurgence of interest.

Left: **"Harold B. Fenner"**

Right: Another from the Combs studio of Evansville, Wisconsin, where "children are a successful specialty" (the pug's chair appears again on page 78).

CIRCA 1895

Photographer's studios located in Hornellsville and Andover, New York

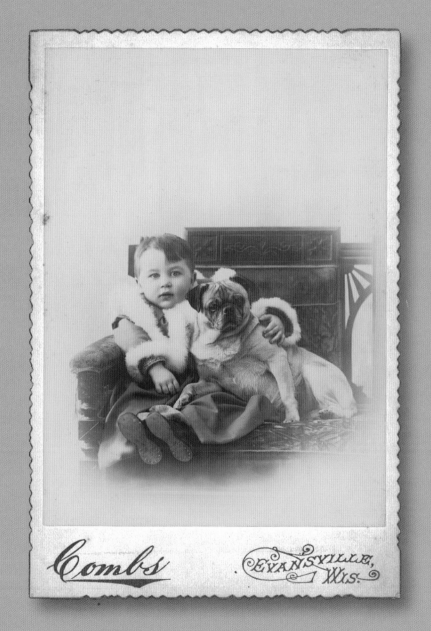

Combs Evansville, Wis.

CIRCA 1888

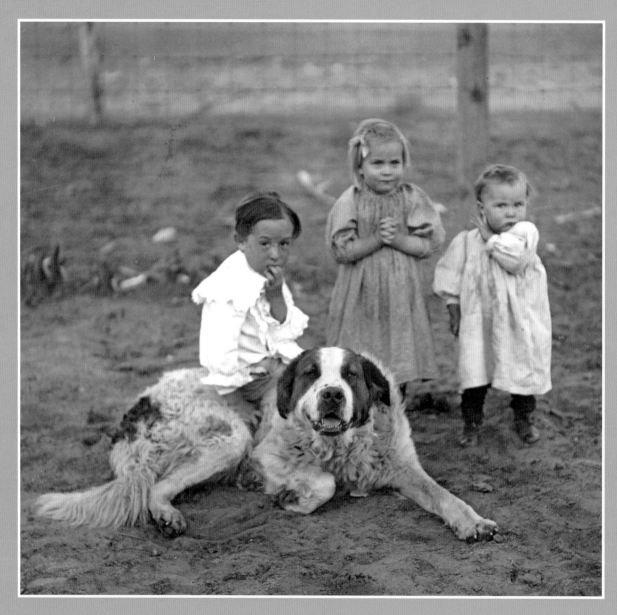

"Clarence, Irene, Wilma, & Nero
Taken May 1907"

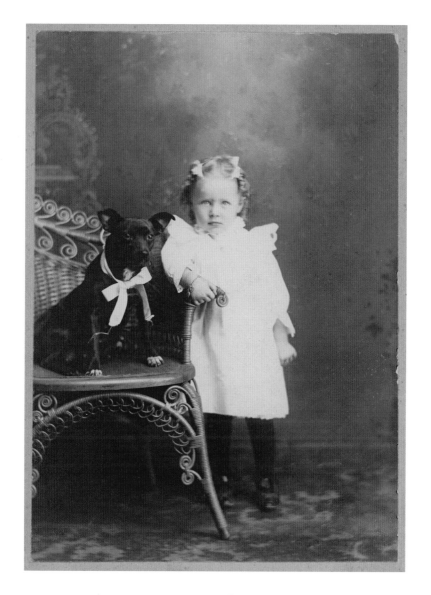

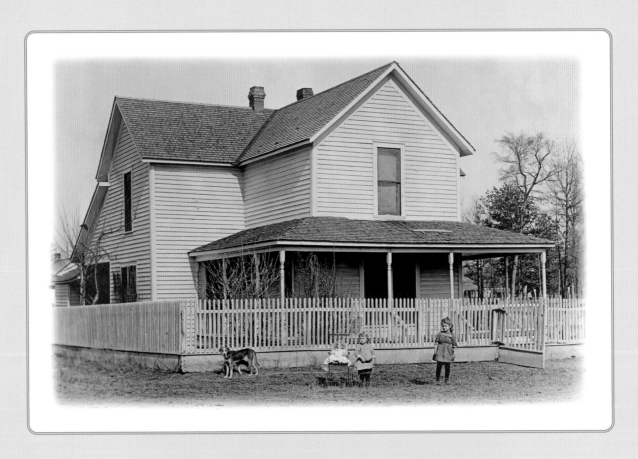

"Ethel Marie & Edward Lafayette. Taken January, 1913."

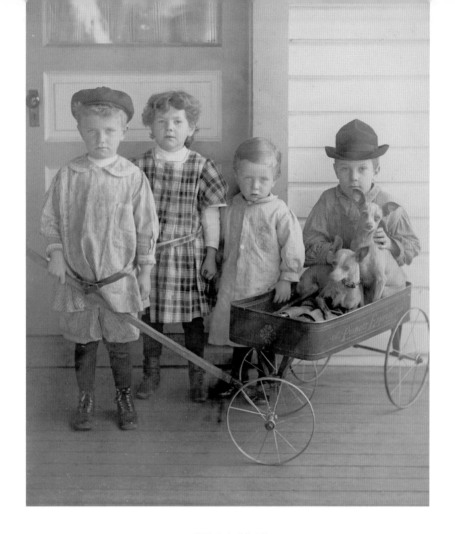

"Harry, Glenn, Marion, Eugene. Children of Cousin Clara Crouch"

Most vintage photographs do not provide enough information for a definitive identification of the child (a name and date are not enough; a parent's name is a crucial piece of the puzzle). In this case, Clara's name is enough to reveal a wealth of genealogical information: Clara and George Crouch were married in Venango, Pennsylvania in 1898, and spent the next eighteen years growing their family. Harry and Marion were born in Venango in 1899 and 1901, Eugene two years later in Ohio, and Glenn just a year later in Florida. Two sisters joined the family in 1911 and 1916.

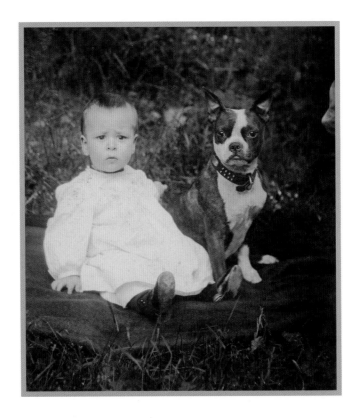

CIRCA 1905

From *The Boston Terrier and All About It. A Practical, Scientific, and Up to Date Guide to the Breeding of the American Dog*, published in 1910:

"Who and what is this little dog that has forced his way by leaps and bounds from Boston town to the uttermost parts of this grand country, from the broad Atlantic to the Golden Gate, and from the Canadian border to the Gulf of Mexico? Nay, not content with this, but has overrun the imaginary borders north and south until he is fast becoming as great a favorite on the other side as here, and who promises in the near future, unless all signs fail, to cross all oceans, and extend his conquests wherever man is found that can appreciate beauty and fidelity in man's best friend. What passports does he present that he should be entitled to the recognition that he has everywhere accorded him? *(Continued on page 77)*

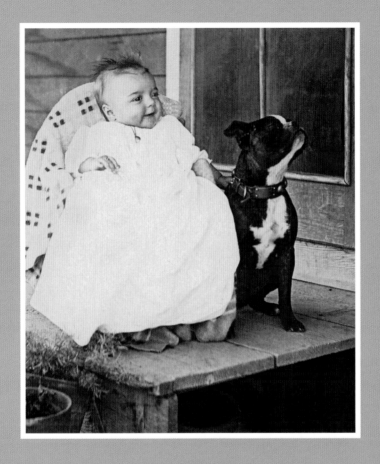

CIRCA 1900—1910

A dog that has in thirty-five years or less so thoroughly established himself in the affections of the great body of the American people, so that his friends offer no apology whatever in calling him the American dog, must possess peculiar qualities that endear him to all classes and conditions of men, and I firmly believe that when all the fads for which his native city is so well known have died a natural death, he will be in the early bloom of youth. Yea, in the illimitable future, when the historian McCauley's New Zealander is lamenting over the ruins of that marvelous city of London, he will be accompanied by a Boston terrier, who will doubtless be intelligent enough to share his grief."

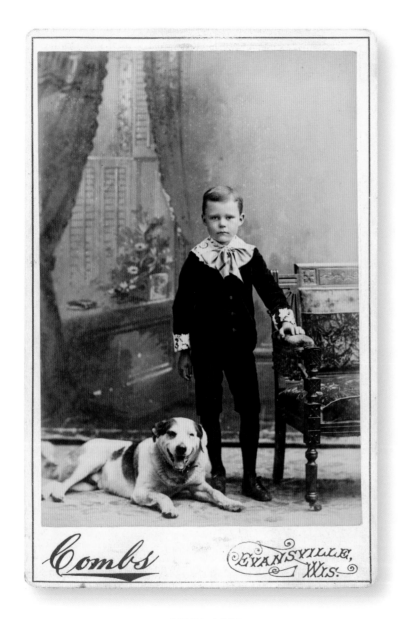

In the 1880s, the Little Lord Fauntleroy look was the height of fashion for boys. (*Little Lord Fauntleroy,* by Francis Hobson Benett, was first published in 1886 and made famous a look that was already popular.) This boy's velvet suit with black stockings and deep, lace collar and cuffs are the epitome of the Fauntleroy craze.

Combs EVANSVILLE, WIS.

CIRCA 1890

Photographer's studio located in Evansville, Wisconsin

E. E. COMBS,
Artistic Photographer,
EVANSVILLE, WIS.

CLOSED SUNDAY.

INSTANTANEOUS PROCESS USED EXCLUSIVELY.

PORTRAITS OF CHILDREN A SUCCESSFUL SPECIALTY.
DUPLICATES CAN BE HAD AT ANY TIME.

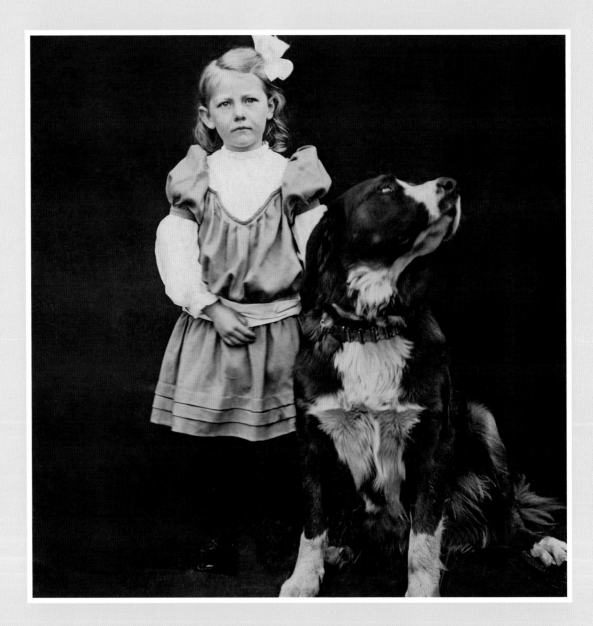

Postmarked July 8, 1907, from Oriskany Falls, New York

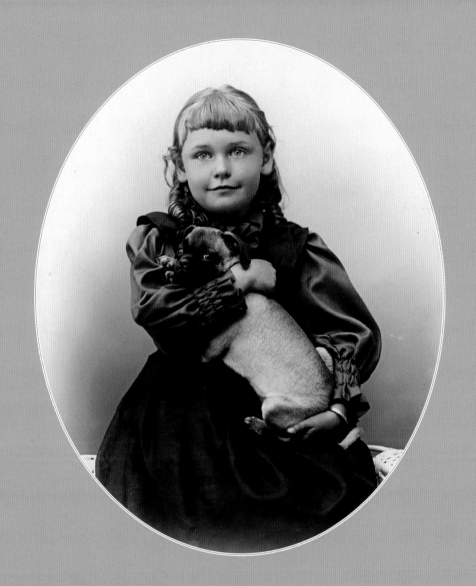

CIRCA 1890

Photographer's studio located in Walton, New York

Another pug enjoying his Victorian heyday (see page 70).

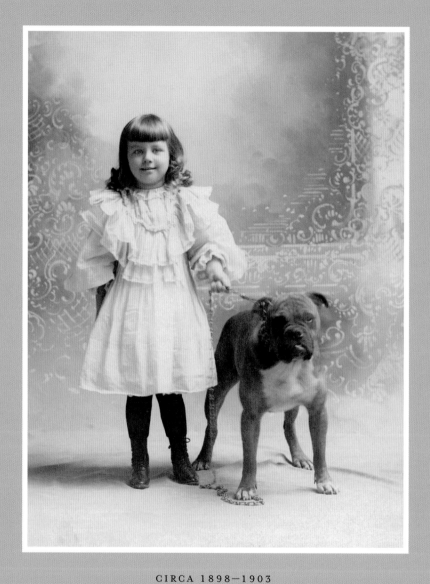

CIRCA 1898—1903

Photographer's studio located in Towanda, Pennsylvania

"Lillie Armstrong, dog Pal"

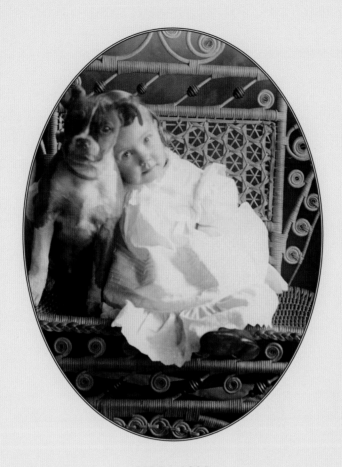

Photographer's studio located in Laconia, New Hampshire

"Katie B. Jewett Colby and Ned"

Boxers were not popular in the United States until after World War I, so these children, Lillie *(left)* and Katie *(above)*, were ahead of their time.

Left: With his droopy jowls and wide stance, Pal has a much more bulldoggish appearance than we see in boxers today. At the time this photo was taken, boxers were not yet recognized by the American Kennel Club, and the dogs tended to have many disparities in appearance.

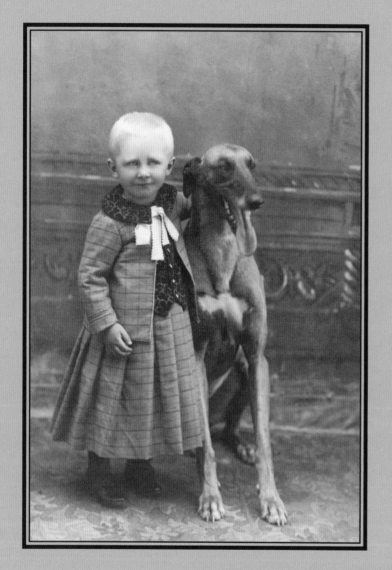

From *Of Englishe Dogges*, published in 1576:

"Of the Dogge called the Grehounde: Among all dogs these are the most principall, occupying the chiefest place, and being simply and absolutely the best of the gentle kinde of houndes."

CIRCA 1888—1890

Photographer's studio located in Mayville, North Dakota

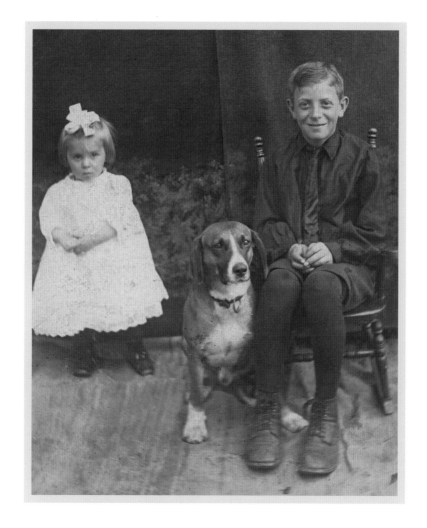

"How are you we are all well up hear.
Just got back from Buffalo last night. When are you coming up?
The baby can talk a leg off of you now.
—From your mother"

Postmarked September 22, 1909, from Slate Run, Pennsylvania

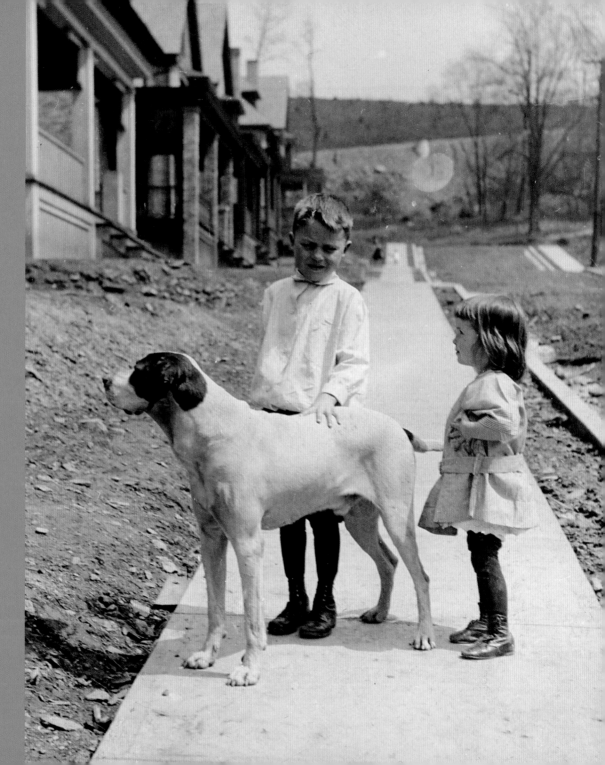

CIRCA 1905

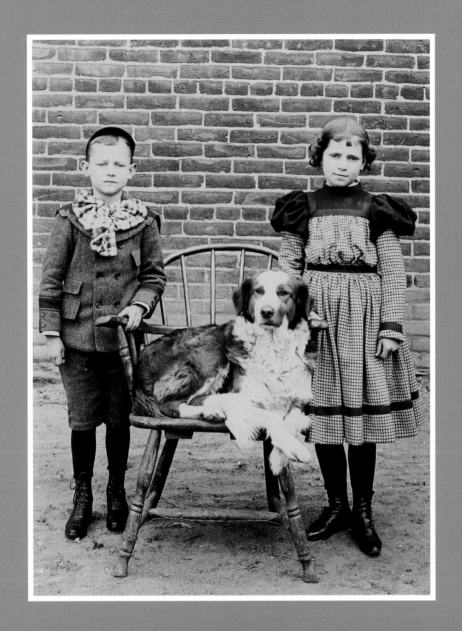

CIRCA 1895—1899

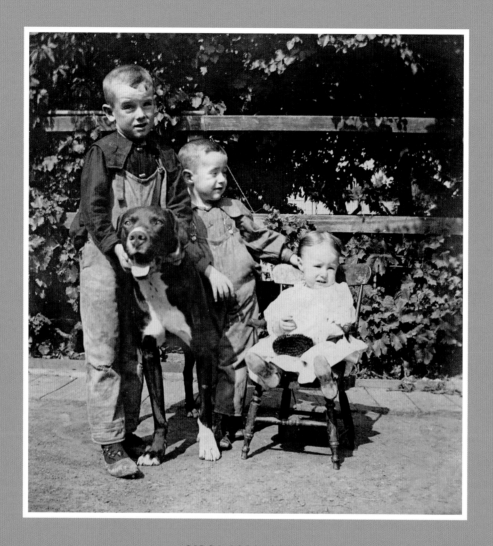

CIRCA 1900–1910

Long-lost littermates? Or is it the same dog? No identification is available for the above photo and all that is known about the photo at right is that the boy was twelve years old and the photographer's studio was located in Fresno, California. The boy on the far left (*above*) has strikingly similar features to the twelve-year-old opposite.

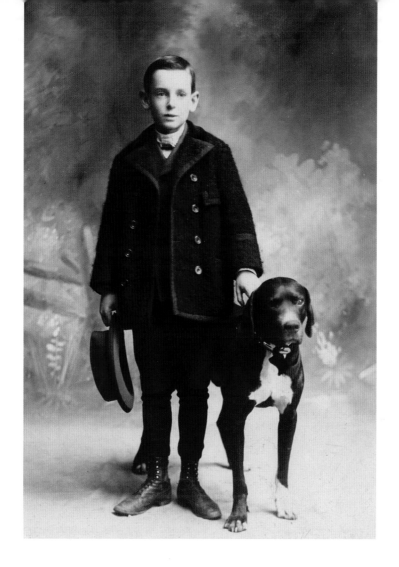

CIRCA 1900—1910

The Raisin City Studio was located in Fresno, California. In the mid-1800s Fresno was—and remains—the premier raisin-producing region of the country.

The dog in each photograph appears to have identical markings. Although it is difficult to discern, there is a large tag hanging from this dog's collar that partially obscures her white chest markings.

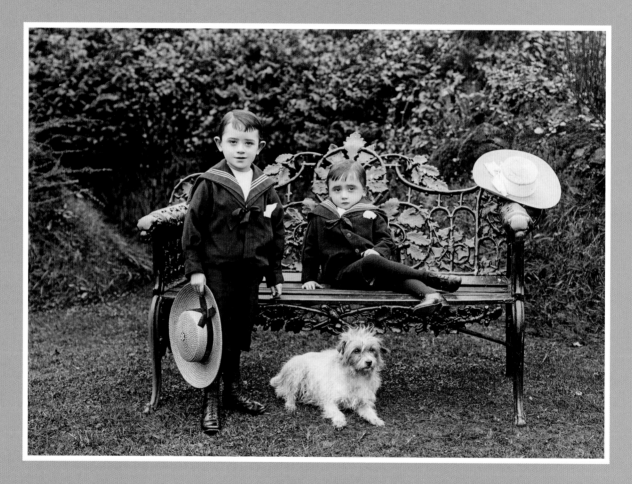

CIRCA 1890

Photographer's studio located in Henley-on-Thames, England

From *Breaking & Training Dogs: Being Concise Directions for the Proper Education of Dogs, Both for the Field and for Companions,* published in 1903:

"The reader will observe that I have said but little about training terriers. The fact is, there is but little to be said about it; as a rule they educate themselves in companionable habits.... They are best fed on scraps from the table, and if you let them *live with you* in the house, they will come to understand your character as well as your nearest and dearest friend, and adapt themselves to your circumstance with even greater patience. I have known a terrier act as an anodyne where a boisterously cheerful companion would have been a bore."

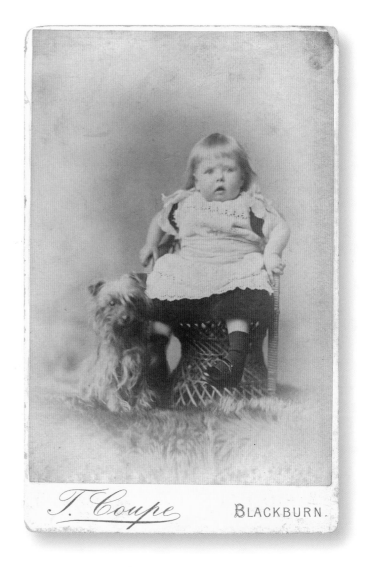

CIRCA 1880—1892

Photographer's studio located in Blackburn, England

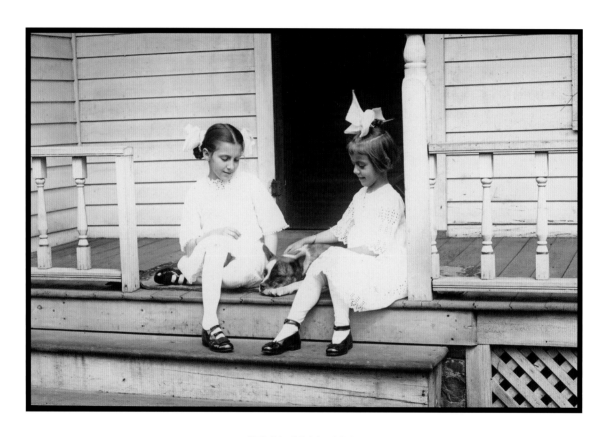

CIRCA 1910—1915

"Hazel 10 years
Helen 7 years"

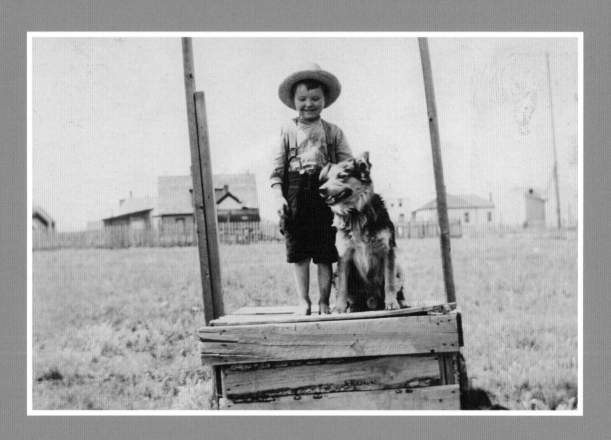

CIRCA 1910

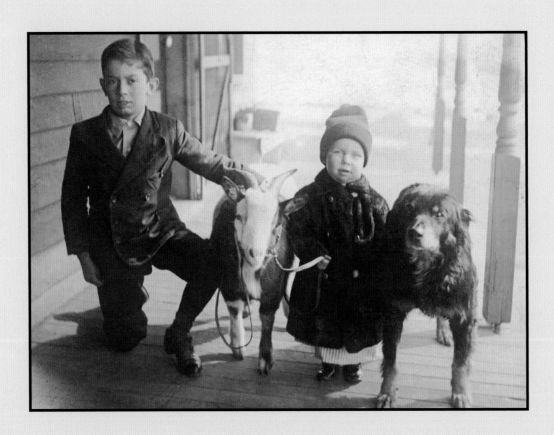

CIRCA 1910

"Randal and Frank Crill"

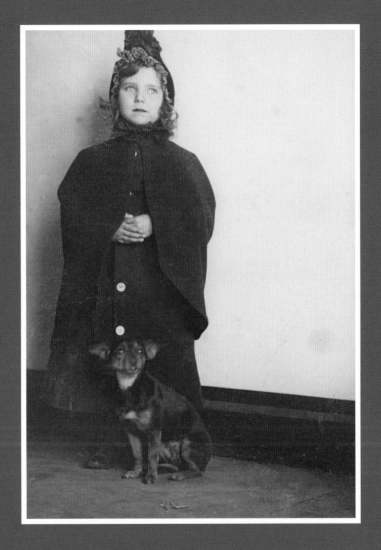

"Best wishes for a happy Xmas and a bright New Year from Janet and Jock."

Postmarked December 24, 1905, at 6:30 P.M. from Pullman, Washington

The substitution of "Xmas" for "Christmas" is often mistakenly assumed to have quite recent origins. In fact, the abbreviation has been used for centuries.

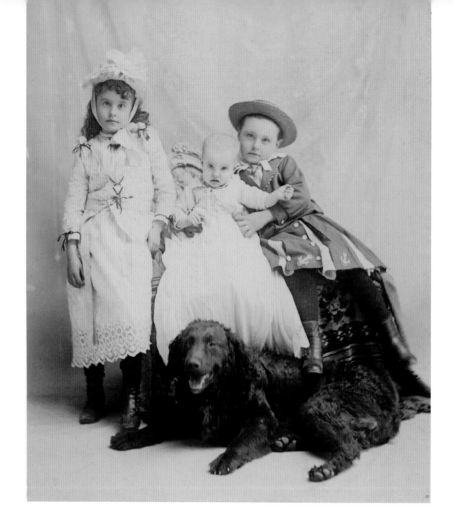

CIRCA 1890—1895

These elegant and fashionably dressed children look as though they came from an affluent family, and the studio's location, Helena, Montana, is a clue that supports this—in the early 1890s, when this photo was taken, Helena was reputed to be the wealthiest city per capita in the United States.

The baby in the boy's arms could be his brother or sister; infants of either gender from wealthy families were dressed in long gowns, a yard or more, that were not shortened to a more practical length until the baby began crawling.

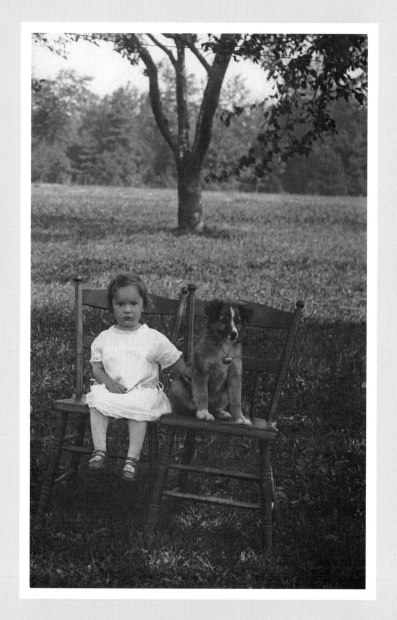

CIRCA 1907—1910

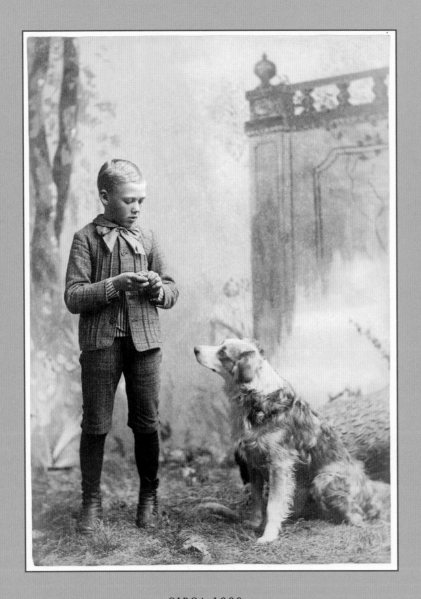

The Australian shepherd and the English shepherd—this attentive fellow could be either—are both, surprisingly, American breeds and would be more accurately known as the American frontier shepherd. Their role throughout rural areas was as all-purpose herding and flock-guardian farm dogs— the "Old Shep" of legend.

CIRCA 1889

Photographer's studio located in Evansville, Wisconsin

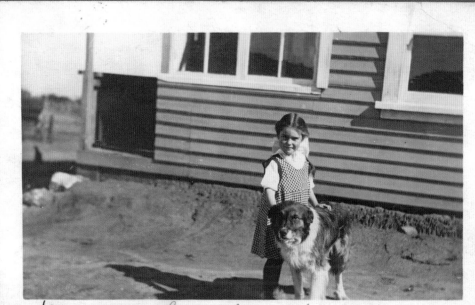

Margy + her dog Jack Feb. 28, 1919

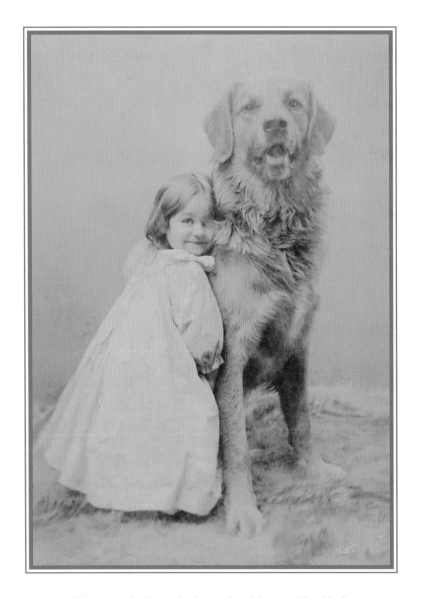

This large and much-loved golden retriever would have been one of the first of his kind to be seen in the United States, because the first goldens didn't arrive from Great Britain until the 1880s.

Photographer's studio located in Marion, New York

"Rachel Tifft and Leone, 1894"

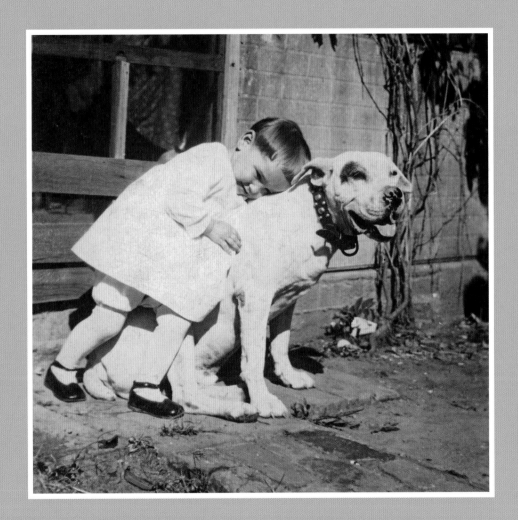

Postmarked November 28, 1921, from Franklin, Nebraska

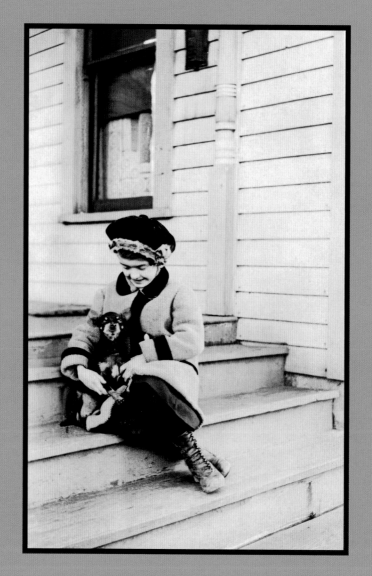

CIRCA 1912

The Chihuahua is one of the few breeds that was initially more
popular in the United States than the United Kingdom.

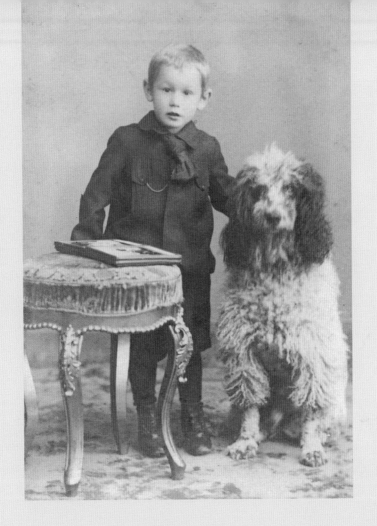

CIRCA 1890

Photographer's studio located in Charlottenburg [now part of Berlin], Germany

From *The Book of Dogs*, published in 1919:

"The poodle is admitted to be among the most intelligent of dogs...and of all dogs these seem to enjoy most keenly the performance of tricks and capers taught by their masters. There is almost no limit to their capacity to learn. In Europe, heavier and more muscular strains of the breed are used as draught dogs, and in parts of Germany there is a strain used for herding sheep."

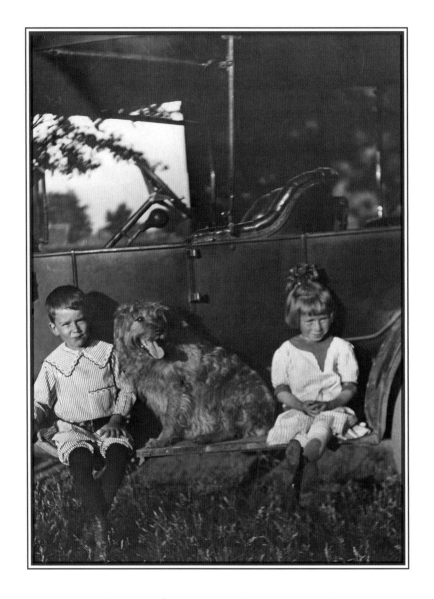

"July 5th 1914 Taken at Elkhart, Indiana"

Above and right: From the same small town, twenty-nine years apart.

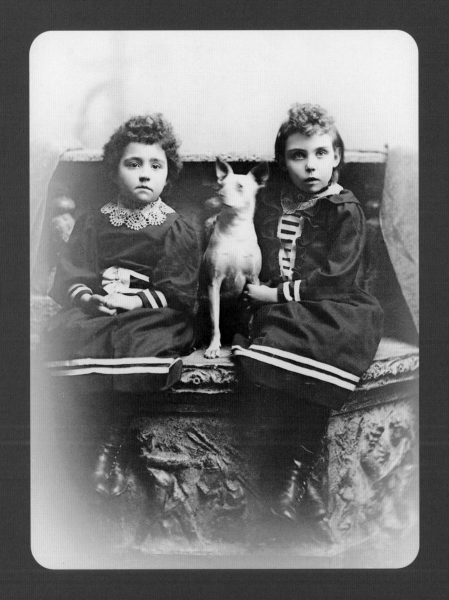

CIRCA 1885

Photographer's studio located in Elkhart, Indiana

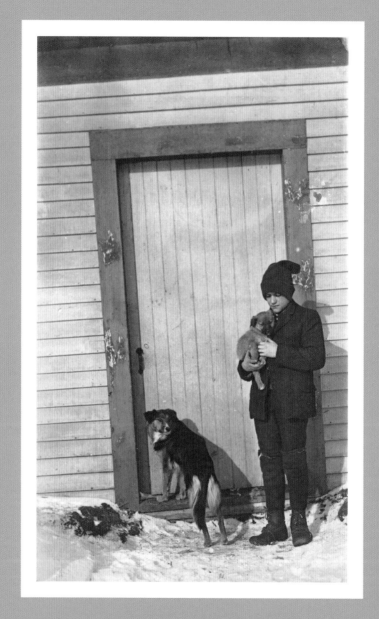

CIRCA 1910

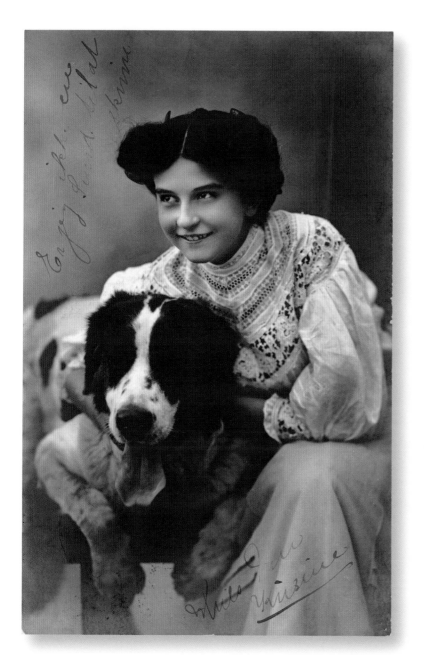

Postmarked June 8, 1909,
from Denmark

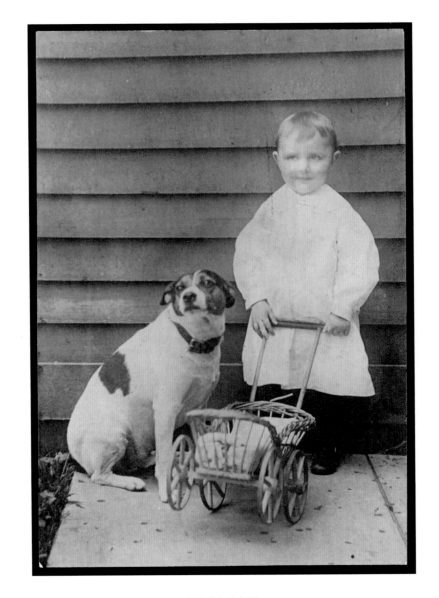

CIRCA 1900

Photographer's studio located in North Liberty, Indiana

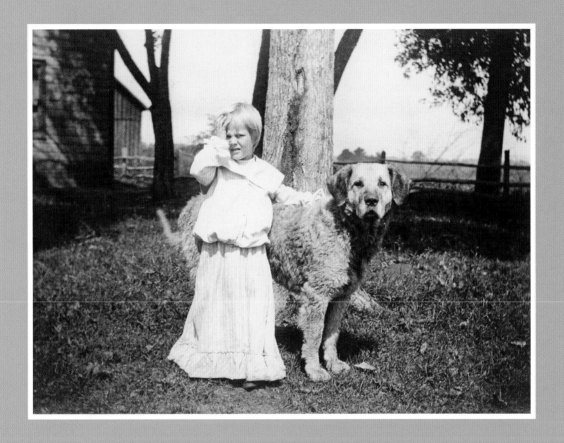

CIRCA 1918

The Chesapeake Bay retriever has a colorful story regarding his origins that is oft repeated among breed fanciers. Apparently, his earliest known ancestors were two puppies saved from a sinking ship off the coast of Maryland in 1807. A sailor from the rescue vessel provided the following account in a letter written years after the incident: "In the fall of 1807...we fell in, at sea, near the termination of a very heavy equinoctial gale, with an English brig in a sinking condition, and took off the crew. The brig was loaded with codfish... and her crew in a state of intoxication." The rescued puppies were sold and soon became famous for their skill in retrieving ducks. By the 1880s, Maryland had its own distinct and highly regarded breed, referred to at that time as the Chesapeake Bay ducking dog.

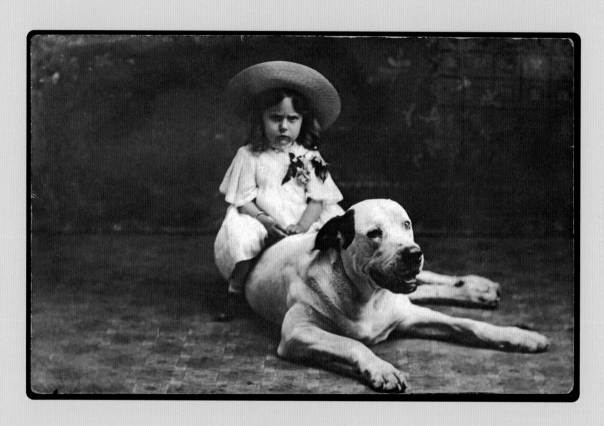

CIRCA 1901—1910

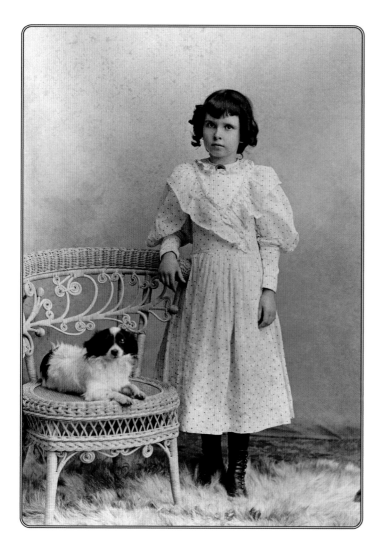

CIRCA 1895

Photographer's studio located in Rantoul, Illinois

**"Blanche Kennedy
Auntie Mac's niece
Lutie (Lucy, called Lutie), her mother,
was a sister of Auntie Mac"**

Thanks to whoever wrote the above family history on the back of the photo, genealogical research unearthed the following: Blanche Kennedy was born May 25, 1887, in New Rockford, North Dakota. She got married in 1907, and died just five years later on January 4, 1912.

Her dog is a toy breed, possibly a Japanese chin, which shares a common ancestry with the Pekingese and the pug.

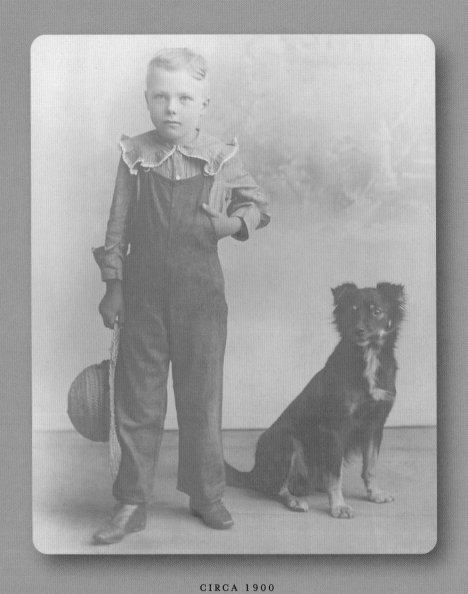

CIRCA 1900

Photographer's studio located in Grand Island, Nebraska

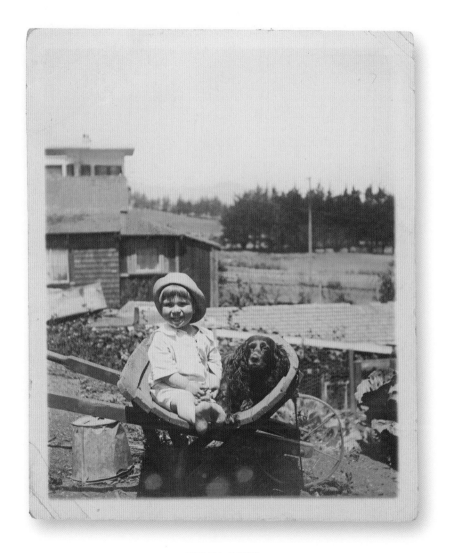

CIRCA 1922

When this photo was taken there was only one kind of cocker spaniel, but by the late 1930s there were two quite different-looking breeds: American and English.

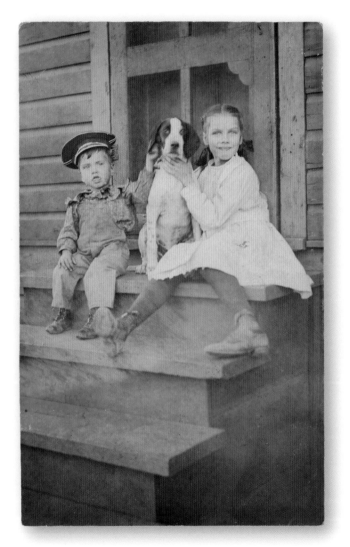

Postmarked November 8, 1909,
from Orlando, Oklahoma

CIRCA 1904

Photography Studios Represented in This Collection

United Kingdom

Blackburn, England: T. Coupe (40 Bank Top)

Harrogate, England: Mark E. Mitchell & Co.

Henley-on-Thames, England: W. Marshall

Reading and Basingstoke, England: Sydney Victor White and
 Ernest E. White

Shepton Mallet, England: J. H. Day & Sons at the Caxton Studio

United States

Adams, Massachusetts: W. D. Parsons

Dallas, Wisconsin: H. H. Denison

Denver, Colorado: Post (1206 15th Street)

Dubuque, Iowa: Mackenzie

Elgin, Texas: Bryan

Elkhart, Indiana: F. L. Goff (217 Main Street)

Erie, Pennsylvania: F. J. Weber & Bro.

Evansville, Indiana: Wm. Buell

Evansville, Wisconsin: E. E. Combs

Frankfort, Kansas: Rice

Fresno, California: The Raisin City Studio (1822 Mariposa Street)

Grand Island, Nebraska: Leschinsky

Hartford, Connecticut: R. J. Davison

Helena, Montana: Taylor

Hornellsville and Andover, New York: Sutton

Indianapolis, Indiana: Mrs. K. Bryant (88 S. Illinois Street)

Jewett City and Moosup, Connecticut: Brown

Kearney, Nebraska: Alfred T. Anderson

Laconia, New Hampshire: G. Wallace Wright

Lowell, Massachusetts: Lothrop & Cunningham (182 Merrimaok St.)

Luverne, Minnesota: Myhre (Cedar St.)

Marion, New York: R. A. Hammond

Mayville, North Dakota: Currier & Parkinson

Michigan Photo Company

Milwaukee, Wisconsin: Koon & Hunt

Minerva, Carrollton, and Malvern, Ohio: Schenck

Minneapolis, Minnesota: Twin City Photo Co.

North Liberty, Indiana: F. M. Tree

New York, New York: Augustus (1168 Broadway)

Portland, Oregon: Alvord (281$^1/_2$ First Street)

Rantoul, Illinois: W. D. La Touche

Rochester, Indiana: G. B. Moore

Russell, Kansas: J. H. Allen

St. Louis, Missouri: When (1631 Franklin Avenue)

Towanda, Pennsylvania: Ott & Hay

Traverse City, Michigan: Wm. Boswell

Walton, New York: G. W. Simpkins Art Gallery

Europe

Aachen, Germany: Atelier Feist

Charlottenburg [now part of Berlin], Germany: Reinhold Schumann

Copenhagen, Denmark: Buchhave

Vienna, Austria: Souvenir

Wiesdorf [now called Leverkusen], Germany: Braschoss